IMAGES
of America

MALDEN

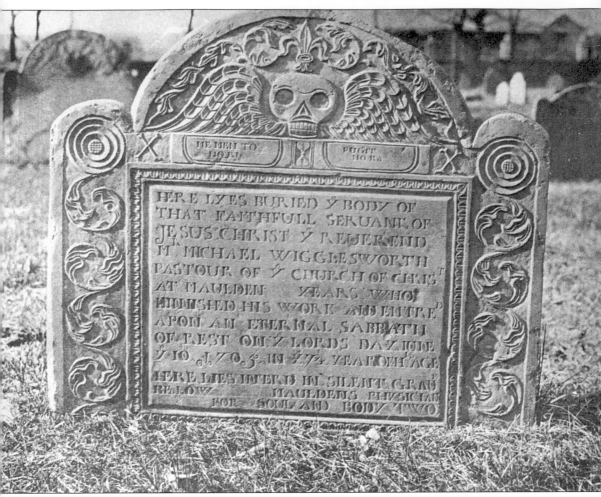

Seen here is the gravestone of Rev. Michael Wigglesworth (1631-1705), "Maulden's physician for soul and body two [sic]," which still stands in Bell Rock Cemetery. Wigglesworth was the third minister of the Malden congregation and the author of the popular poem "Day of Doom," published in 1662.

IMAGES
of America

MALDEN

Malden Historical Society

ARCADIA

Copyright © 2000 by Malden Historical Society.
ISBN 0-7385-0405-X

First printed in 2000

Published by Arcadia Publishing,
an imprint of Tempus Publishing, Inc.
2 Cumberland Street
Charleston, SC 29401

Printed in Great Britain.

Library of Congress Catalog Card Number: 99-069233

For all general information contact Arcadia Publishing at:
Telephone 843-853-2070
Fax 843-853-0044
E-Mail sales@arcadiapublishing.com

For customer service and orders:
Toll-Free 1-888-313-2665

Visit us on the internet at http://www.arcadiaimages.com

CONTENTS

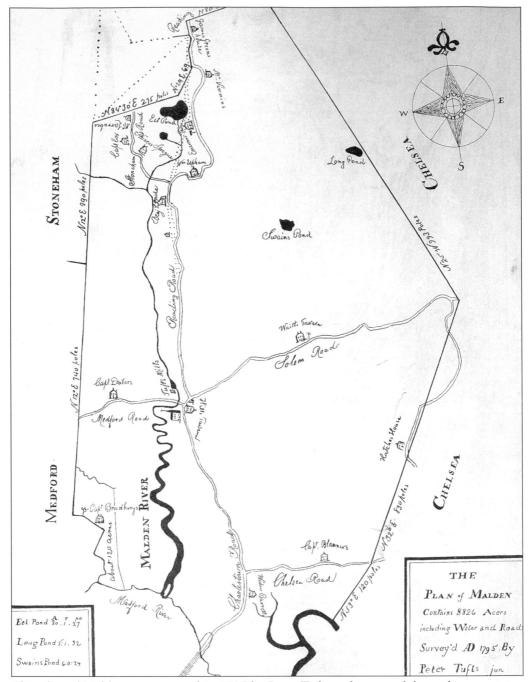

This plan of Malden was prepared in 1795 by Peter Tufts and is one of the earliest surviving maps of Malden. As seen here, Malden then included within its boundaries the present-day cities of Melrose and Everett.

INTRODUCTION

When the early settlers from Charlestown arrived in Malden in the 1630s, they found a land dotted with hills and crossed by ponds, streams, and a river that ran to the sea. The character of the land and river directed the development of Malden. It was not a good place for large farms, and the river was not deep enough for shipbuilding. However, there was plenty of waterpower for mills and factories. The town, named by Joseph Hills for his hometown in Essex, England, flourished as a business community. In addition to some small-scale farming, fishing, and lumbering operations, Odiorne's Nail Mill, Barrett's Dye House, and Coytmore's Mill achieved a place of significance in Malden's early history as much as the Boston Rubber Shoe Company and the Converse Rubber Company did years later.

Consequently, Malden developed persons of wealth and influence who gave the community many of its lasting institutions. Timothy Bailey, a tinker, founded the first bank in Malden. One of Malden's present banks evolved from this bank. Elisha Converse, Malden's first mayor, and his wife, Mary, donated the Converse Memorial Building to the Malden Public Library in memory of their slain son. Albert Davenport, the famous furniture designer and manufacturer, built his home in Malden.

As businessmen made their fortunes and built grand houses on Belmont Hill and in the West End, workers made their living in the factories. Ambitious immigrants started their own smaller, neighborhood businesses. Maplewood's Scandinavian community, Edgeworth's Irish and Italian communities, and Suffolk Square's Jewish community all added to the diversity of Malden in the late-19th and early-20th centuries.

From its beginnings, Malden developed as a business community, which resulted in it becoming modern and forward-looking. Much of the past was lost while moving forward. Few early houses remain; businesses came and went; the face of the community changed continually; and urban renewal eradicated whole areas. This book contains photographs of many lost memories, both of place and of time. It is hoped that it will cause the reader not only to enjoy but also to pause and reflect on what has gone before in Malden.

ACKNOWLEDGMENTS

The Malden Historical Society wishes to acknowledge its publication committee for the preparation of this work: Frank Russell, chairman, and members Barbara Tolstrup, Anthony Tieuli, John Tramondozzi, and Brenda Howitson-Steeves. The society would also like to thank the librarians and staff of the Malden Public Library; the families and friends of the committee, who put up with a lot of home absenteeism; and all those who encouraged the undertaking of this task, especially the Board of Directors of the Malden Historical Society.

The Malden Historical Society is located in the Converse Memorial Building of the Malden Public Library. Donations to the society of photographs, artifacts, and other memorabilia are greatly appreciated and help to preserve Malden's history for future generations. You may contact us by writing to the Malden Historical Society, 36 Salem Street, Malden, Massachusetts 02148, or by telephoning (781) 338-9365.

One

EARLY HOUSES
AND HISTORY

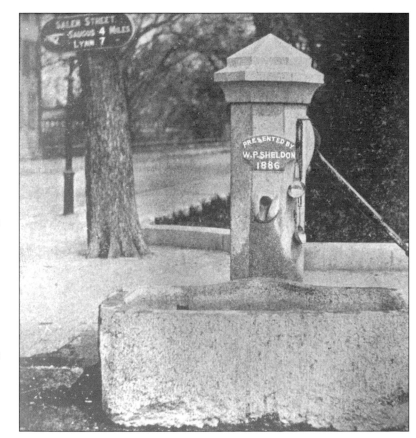

The town pump was located on the north corner of Salem and Main Streets near the First Baptist Church. It was originally the well of Joseph Hills, one of Malden's first settlers. It was removed in 1894 when the street was widened to accommodate a trolley line.

The Green-Perkins House was located at 51 Appleton Street. Built in 1649 by James Green, the house was purchased by Joseph Perkins in 1765. It was the oldest house in Malden when it was demolished in the 1950s.

The Joseph Lynde house was originally located on Main Street across from the Pine Banks Park ball fields. It was razed in the 1950s. This was one of a number of Lynde family houses in the area. The Lynde family owned most of Malden north of Waitt's Mount. Two Lynde houses are still in existence in Melrose, which was originally known as North Malden.

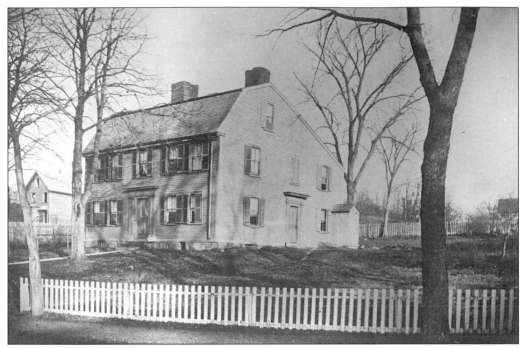

Waite's Tavern, pictured here, was the second house to be operated as an inn by the Waite family. The first tavern was opened by Samuel Waite in 1719. It burned and a new house, seen here, was built and began operating as an inn in 1789. It was closed by Aaron Waite, a wealthy Salem merchant, and later demolished by Levi Rockwell in 1891. It was located on Salem Street, roughly opposite Webster Street.

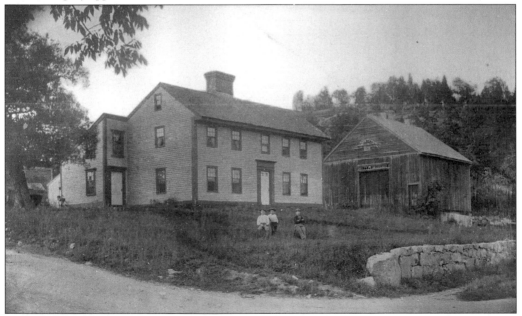

The Deacon Waite House, also known as the Faulkner Farmhouse, is seen here on Salem Street at Pierce Street, c. 1870. This was later the site of the Faulkner School and is currently the site of the Salem Towers apartment building.

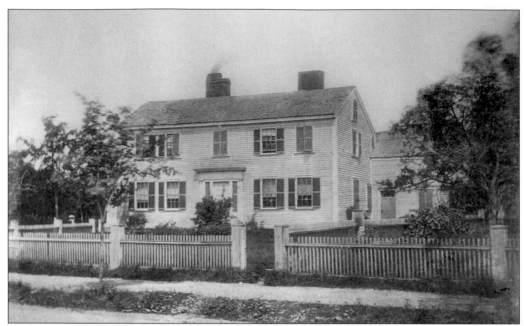

This 18th-century colonial house is believed to be the Stiles House, now located on Meridian Street, having been moved from its original location on Main Street. It is one of a very few houses dating from the 1700s still standing in Malden.

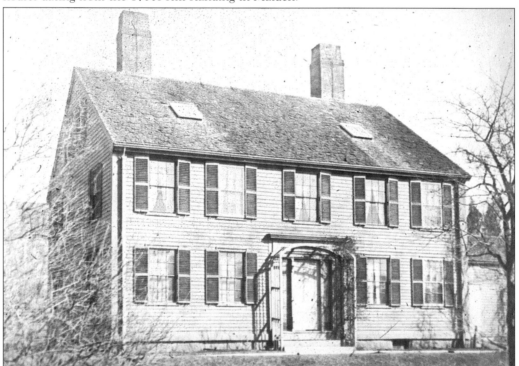

The Hartshorn House on Orchard Street is one of the oldest houses in Maplewood. It is also known as the Darius Waite House. The house originally stood facing Lebanon Street but was moved back from the corner to its present site.

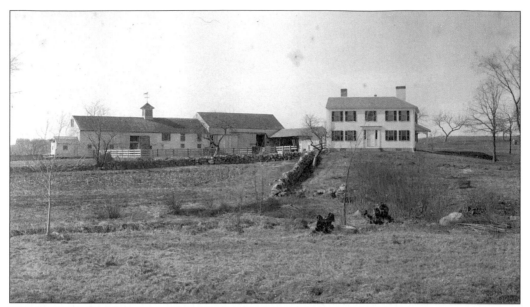

The Sammett Farmhouse is still located at 68 Newton Street in what is today Everett. The farm had a storied history in the early settlement of Malden. The land had been a 17th-century land grant, which descended through the Greenland and Shute families. The house was built in 1810 by Henry Rich, and the farm survived into the 1920s. Until 1870, Everett was part of Malden.

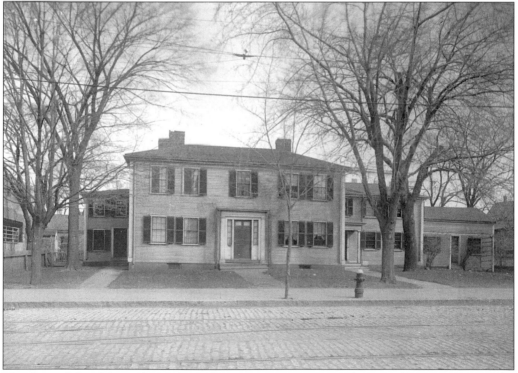

The Samuel Cox House, located on Pleasant Street, is seen in this view from 1899. Cox, who also built the Cox Last Factory, a large 19th-century Malden business, built the house in 1812.

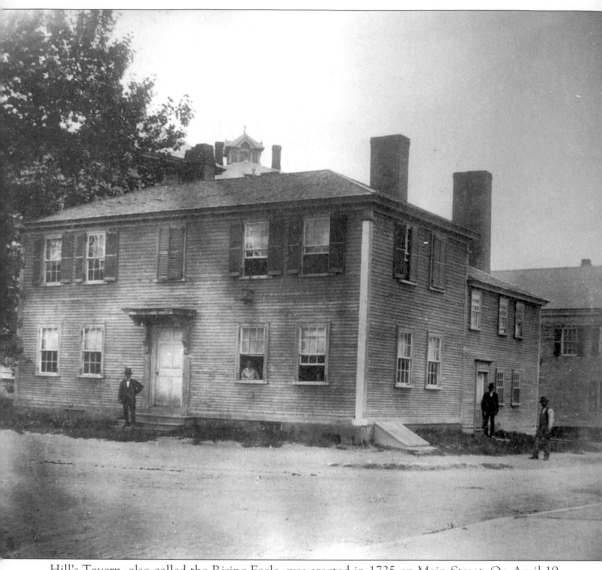

Hill's Tavern, also called the Rising Eagle, was erected in 1725 on Main Street. On April 19, 1775, it was the meeting place of the Malden Militia, under the command of Capt. Benjamin Blaney. In 1857, to allow for the construction of the old city hall, the tavern was moved to the corner of Irving Street, where it remained until demolished in 1914. John Adams visited here.

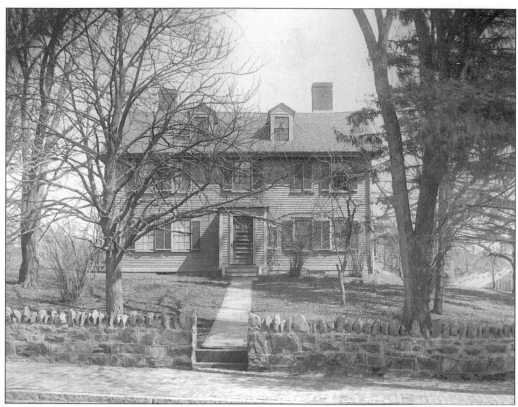

The Parsonage, also known as the Judson House, was built in 1725 and was the second house on this site. The house was long used as the parsonage for Malden's ministers. It is Malden's oldest complete house today and sits on Main Street across from Bell Rock Park. The first occupant of this house was Rev. Joseph Emerson, an ancestor of Ralph Waldo Emerson.

Adoniram Judson, who lived from 1788 to 1850, was the son of Adoniram Judson, a pastor of the Malden Church from 1786 to 1791. The younger Judson was born in the Parsonage in 1788 and became a celebrated Baptist missionary to Burma, enduring arduous circumstances while there. Judson was the first to translate the Bible into Burmese, and he developed an English–Burmese dictionary.

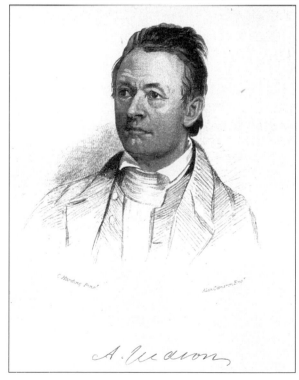

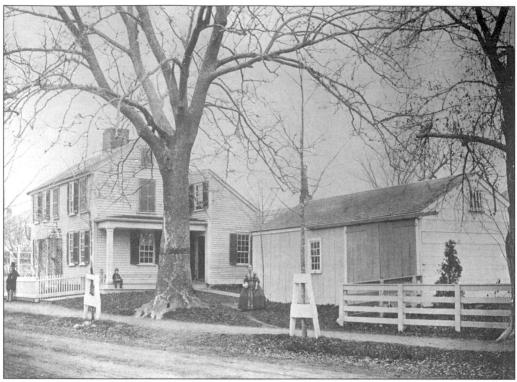

The Sprague House, seen in a view from 1868, was built by Joseph Dyer *c.* 1796 to 1800 at the corner of Salem and Sprague Streets. In the picture, Phineas Sprague is standing on the sidewalk, his son John is on the step, and Abigail (Sprague) Emerson is standing on the lawn.

The Scotch-Boardman House, built in 1687, reflects the English architectural style brought to the colonies by the early settlers. No home that dates from the 1600s still stands in Malden. This home, still standing, is on the Melrose–Saugus line.

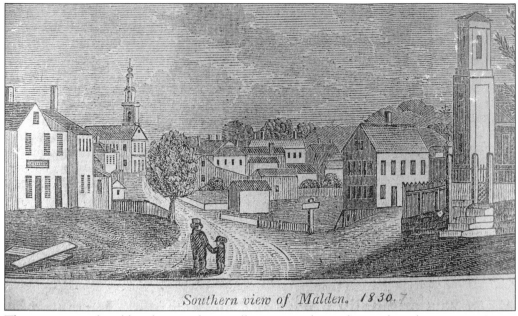

Southern view of Malden. 1830.

This is a view of Malden from Bailey's Hill *c.* 1830. This early woodcut shows Main Street looking north from the present-day intersection of Madison Street on the left and Eastern Avenue on the right.

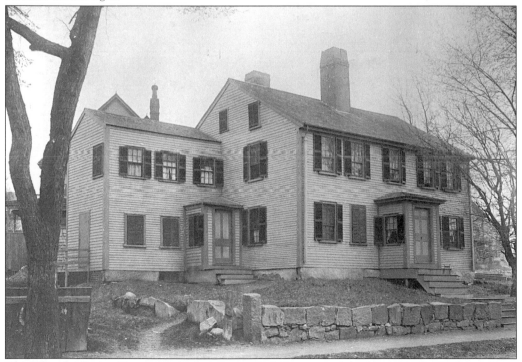

The Timothy Bailey House was built prior to 1795. It was purchased by Timothy Bailey in 1819 and used as a tin shop. Later it became the site of the first bank in Malden, which was called the Malden Agricultural and Mechanic Association. In 1858, the house was moved from Main Street to Madison Street. It was demolished in the 1990s.

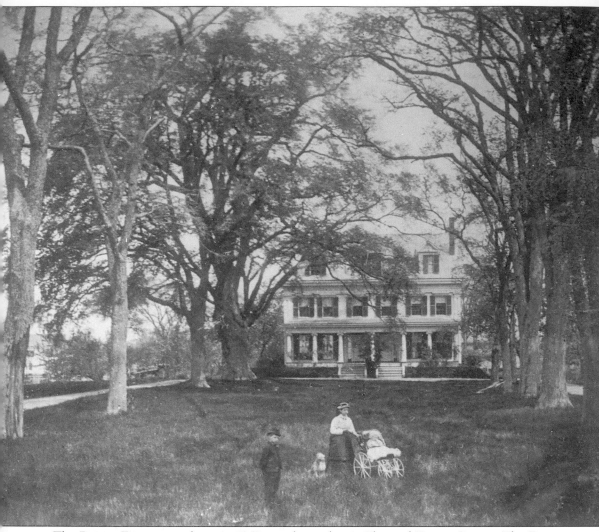

The Dexter Estate, seen here in 1869, was located near Elm and Dexter Streets. The Dexter family owned a large farm in the area north of Pleasant Street. The house was demolished c. 1945 and is currently the site of the Dexter Estates condominiums. George Washington was entertained by the Dexter family in an earlier house located on this site.

Two

PHOTOGRAPHS
BY E.C. SWAIN

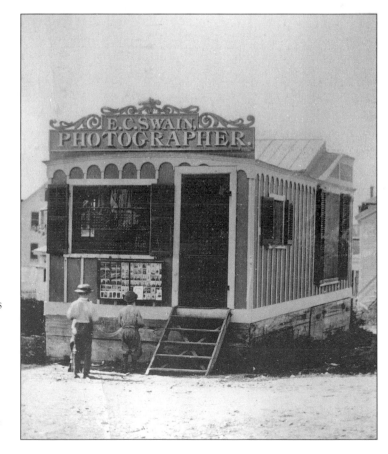

E.C. Swain's photography car on Pleasant Street is seen here in 1867. At the time, it was the only photography studio in Malden. Swain was the most prominent of a number of photographers who documented Malden's early development. Examples of his photographs, originally done as stereo views, show Malden in its nascent development and are presented on the following pages.

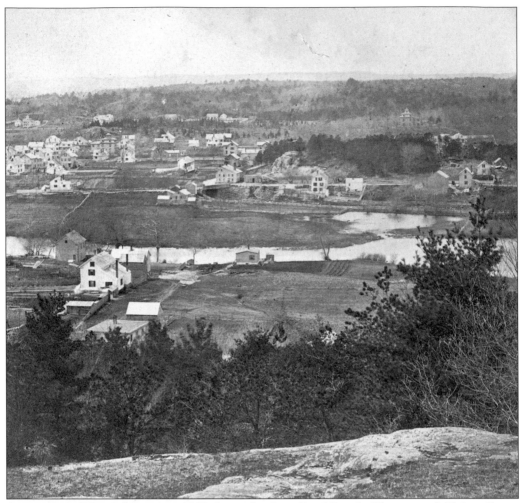

A view from Waitt's Mount in 1867 shows the Spot Pond Brook. The original Clifton Street railroad bridge is visible in the center. Note the wide flood plain around the brook. Flooding in the area was common, and there were several small ponds in the area due to its low-lying topography. Washington Street runs from left to right just above the middle of the photograph.

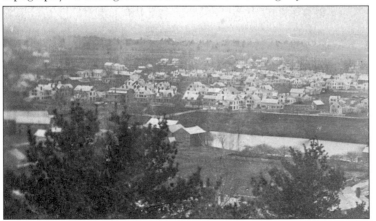

A view of Malden looking southwest from Waitt's Mount again shows the Spot Pond Brook, as well as Linden Avenue and Washington Street in the vicinity of Mountain Avenue.

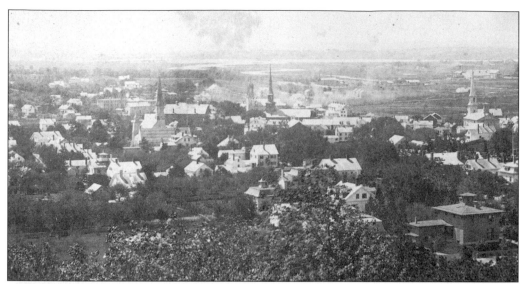

Malden Center in 1866 is seen in this view from Waitt's Mount. From left to right can be seen the steeples of the Baptist church, the First Parish Universalist Church, the First Church Congregational, and the Centre Methodist Church.

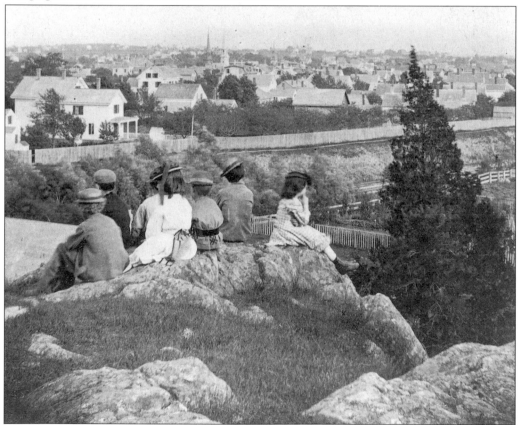

This photograph was taken from above the Clifton Street Bridge, which crosses over the Boston & Maine Railroad.

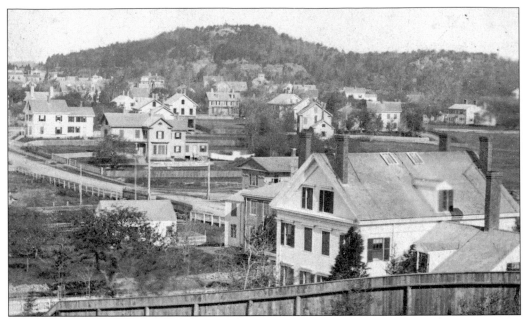

Waitt's Mount is in the distance in this view from Powder House Hill in 1867. Powder House Hill was also known as Liberty Hill. Both names have long since passed into disuse; the area is the top of Hillside Avenue today.

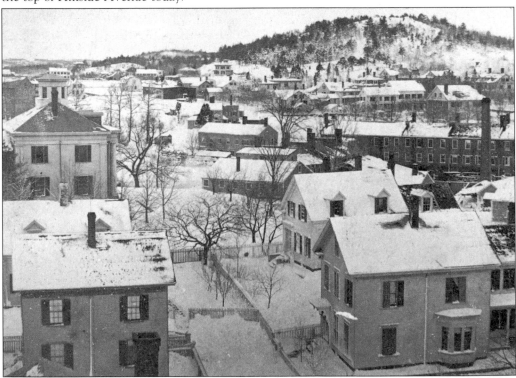

Waitt's Mount was photographed from the Methodist church belfry in 1871. Originally called Mount Prospect, Waitt's Mount was variously spelled as Wayte's or Waite's Mount in the past. During the Revolutionary War, a beacon fire was located at its summit.

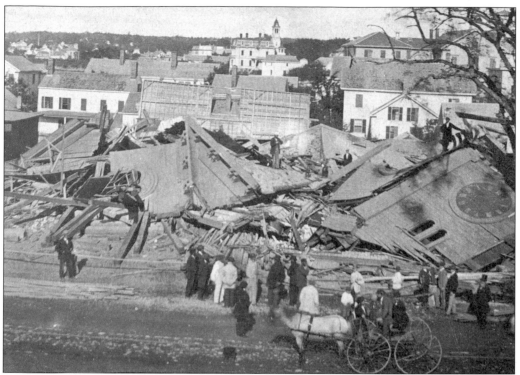

In this photograph from 1869, the First Church Congregational, then located on Main Street opposite Irving Street, is seen in ruins after it was destroyed by a gale.

This view of Malden Square taken in 1866 shows the Baptist church and the Town House, recalled by many today as the old city hall. The view was taken from Main Street just south of Pleasant Street, looking toward Converse Square. The intersection of Main and Pleasant Streets was called Central Square.

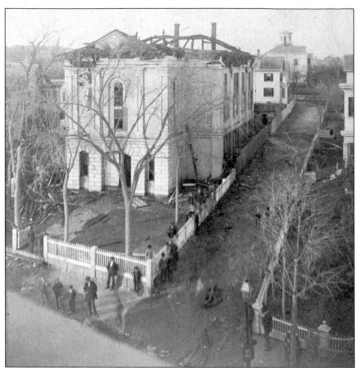

The Methodist Church on Pleasant Street is seen in this photograph taken after the fire of 1876, which destroyed the structure. It was located between Garnet and Waverly Streets.

A new Centre Grammar School was under construction in the autumn of 1875. The school was located on Ferry Street on the present site of Monsignor Foley Hall and the addition to Chevrus School.

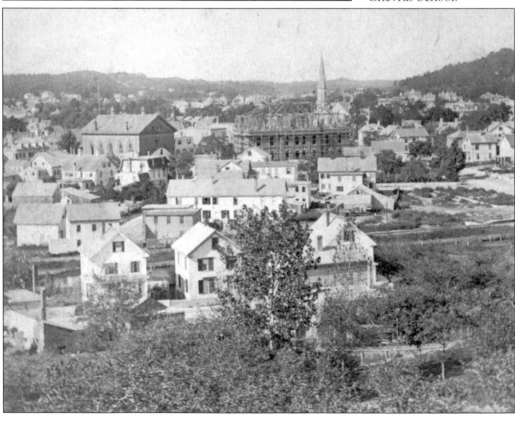

Washington Street in winter, looking north from Pleasant Street, is shown in this view taken *c*. 1880. The new Centre Methodist Church, built after the 1876 fire, is visible on the right.

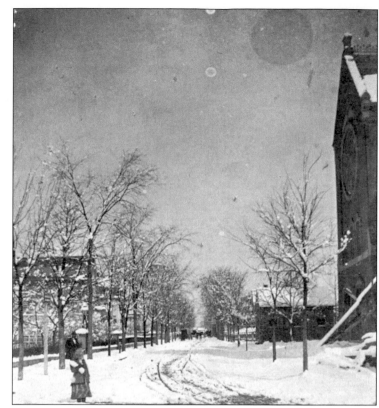

The Odd Fellows Parade is assembled on Pleasant Street *c*. 1870. Main Street is in the background. The group is standing in front of Jackson's livery stables, now the block containing the Malden Jewelry Store and the Varnick Building.

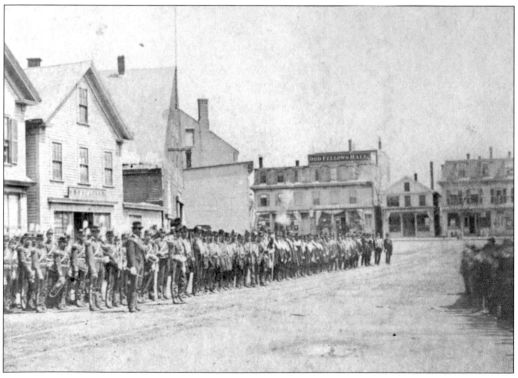

This photograph shows, from left to right, Shiloh's Barbershop, E.C. Swain's photographic studio, and the Centre School. The school was built in 1848 and was destroyed by fire on January 19, 1873. Located on the south side of Pleasant Street, the site today lies between Middlesex and Washington Streets, opposite the Pleasant Street parking lot.

Three
CHURCHES AND SCHOOLS

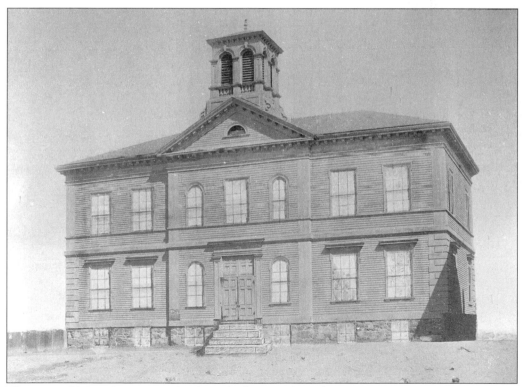

The original West Grammar School was built in 1865 on Pleasant Street. In 1884, it was moved to a lot on the south side of Chester Street to make way for construction of the new West School, later renamed the Leonard School. The 1865 structure was moved once again in later years to the Marsh, an area near Jackson and Middlesex Streets.

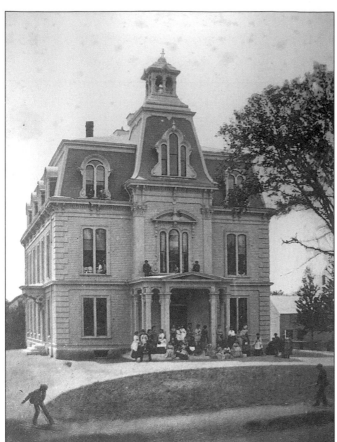

The original Malden High School, located on Salem Street, was erected in 1872. Prior to occupying this building, high school classes were held in the original Centre Grammar School on Pleasant Street and, later, in the Town House.

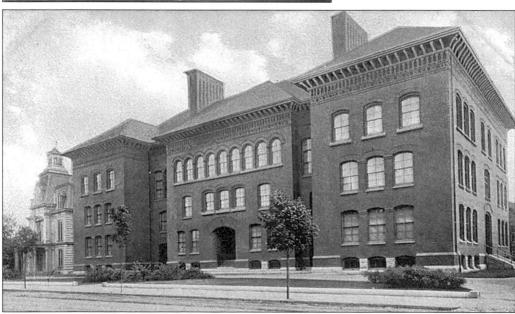

Malden High School is shown here in 1905. On the left is the original 1872 wood building and on the right, the 1899 brick building.

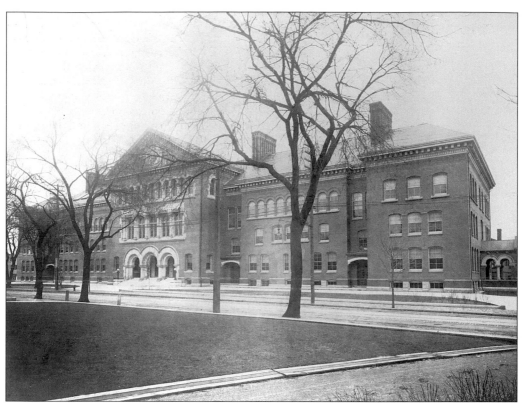

Malden's population grew so rapidly that in 1908, a substantial enlargement of the 1899 brick building was necessary. Note that the entrance in the 1899 brick building, seen in the previous photograph, is now bricked up on the right side of the enlarged high school.

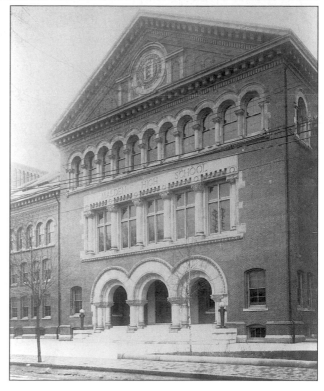

This photograph presents a detail of Malden High School, showing the city seal carved of Indiana limestone. From 1908 until 1979, the seal graced the peak of the high school. After the demolition of the red brick high school, the seal lay in pieces for many years in the city yards. It was placed in its present site on the high School grounds at the corner of Ferry Street in 1993.

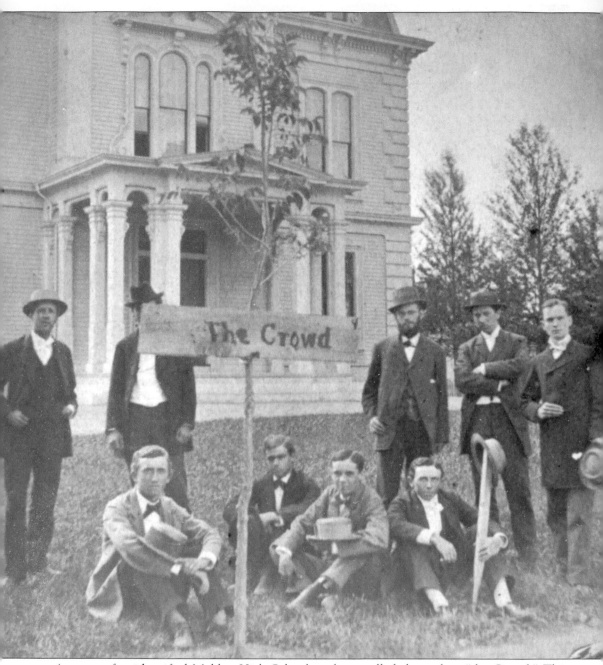

A group of unidentified Malden High School students called themselves "the Crowd." This view, dating from *c.* 1880, confirms that even then high school students had diversions from their studies.

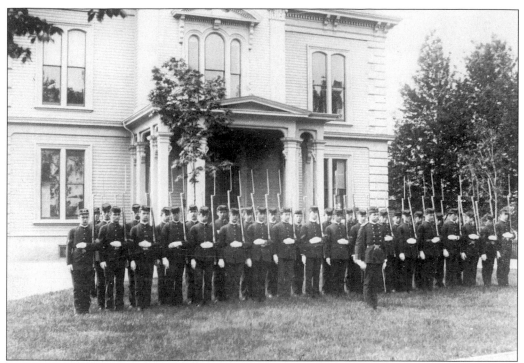

Malden High School cadets are seen on Decoration Day in 1886. From the end of the Civil War until *c.* 1900, high school drill teams, or battalions, were more popular than school sports teams.

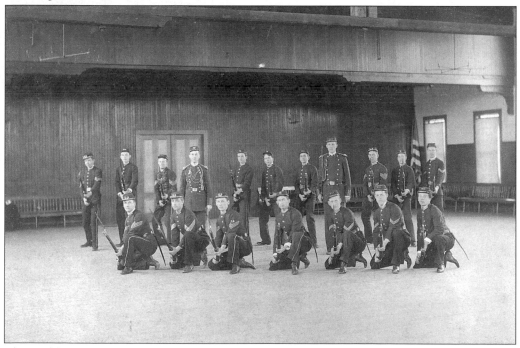

The Malden High School bayonet squad is shown here in 1892. Col. Henry A. Waterman is the commander.

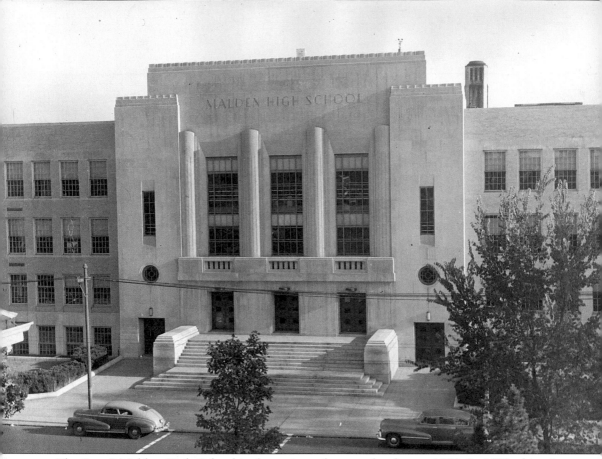

The "new" Malden High School is shown in a photograph taken c. 1950. In 1939, this wing was added to the high school by the Works Progress Administration and the original 1872 wooden high school was demolished. Currently used as the Malden Middle School, the structure remains a fine example of art deco architecture.

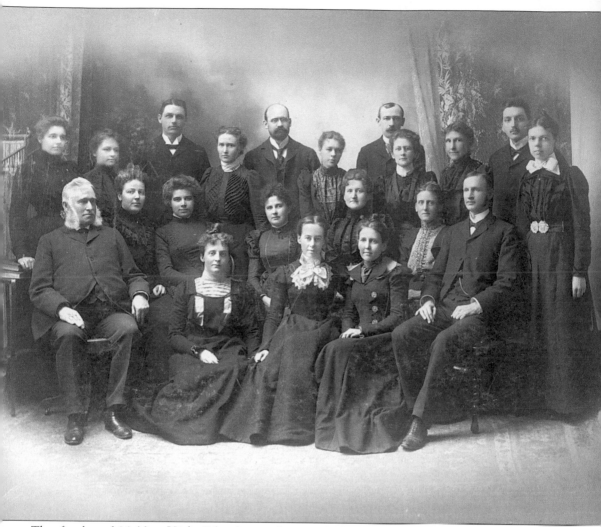

The faculty of Malden High School was photographed in 1899. Charles A. Daniels, the superintendent of schools, is seated on the left, and John W. Hutchins, the principal, is seated on the right.

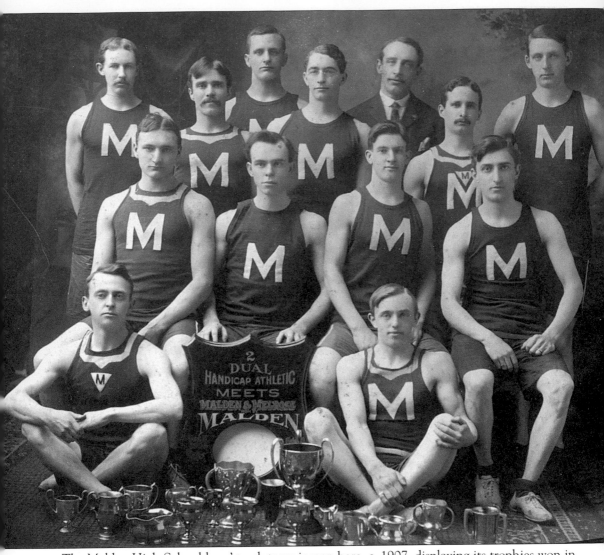

The Malden High School boys' track team is seen here, *c.* 1907, displaying its trophies won in recent matches against Melrose.

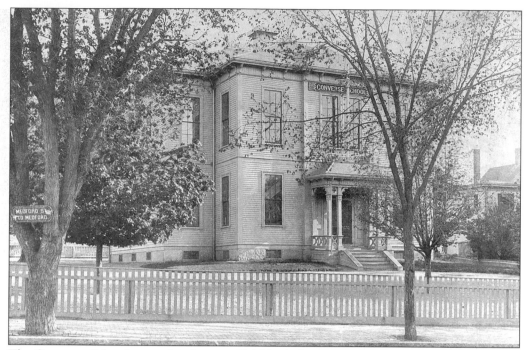

The Converse School, named in honor of Malden's first mayor, Elisha Converse, was located at the corner of Medford and Main Streets. In the early-20th century, students from this Belmont Hill area attended the Converse School or the Belmont School on Cross Street, sometimes attending one and then the other for alternating grades. The Converse School site is now occupied by an apartment building.

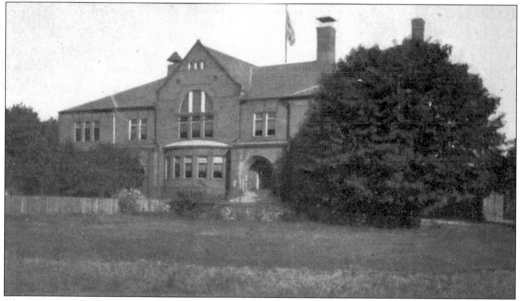

The West School, built in 1884, was so named because it was located in the western part of the city and was located on Pleasant Street across from the present Beebe School. The principal for many years was Laura A. Leonard, and the school was renamed in her honor after her death. In the 1980s, the school was taken out of use and converted into a professional building.

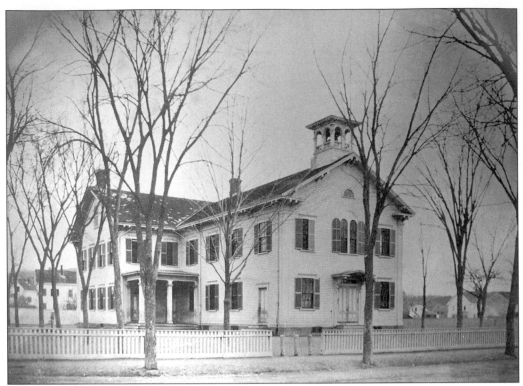

The Maplewood Grammar School is seen here in 1880. Built in 1857, it was moved in 1886 to allow for the construction of a red brick school. It stood on the site that is occupied today by the Maplewood School.

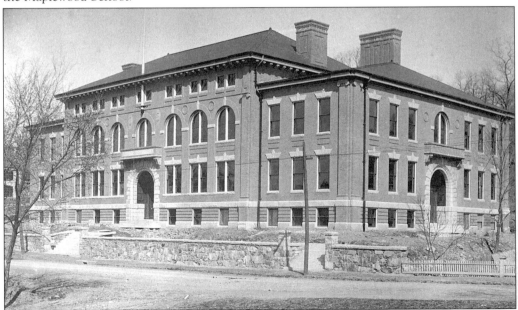

The Glenwood School was erected in 1898 in response to the rapid growth in population due to the many new homes being constructed in Malden's West End. It replaced the Oak Grove School. The 1999–2000 school year was the last year of the school's service.

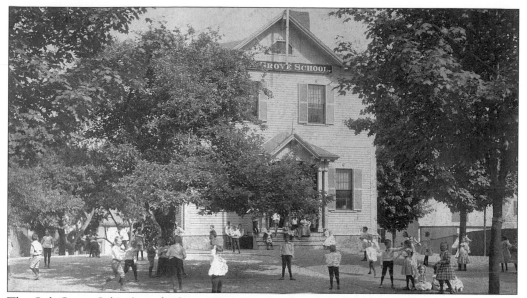

The Oak Grove School was built on Wyoming Avenue opposite Gleason Street as a two-room school in 1872. It was closed when the Glenwood School opened in 1898. Mary Proctor, the principal, is seen here sitting on the step.

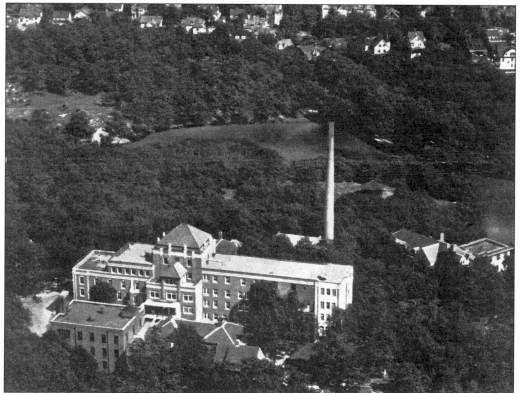

The Malden Hospital opened its doors in 1892 on land donated by Malden's first mayor, Elisha Converse. By 1934, it had developed into a large community hospital. The buildings seen here were removed in the early 1990s for the hospital's expansion.

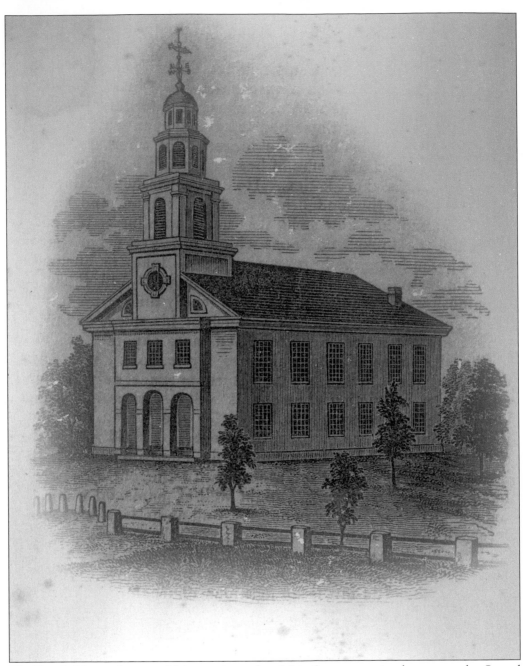

The Fourth Meetinghouse, which was situated on Main Street opposite the present-day Sacred Hearts Church, is seen in this view from 1848. It was built in 1802 and demolished in 1911. Before the erection of the Town House in 1857, this structure served also as the site of town meetings. It originally housed the Malden Church and after 1828, the First Parish Universalist Church. The building was remodeled in 1857, as shown on page 44.

The First Church Congregational was built in 1833 at the corner of Main Street and Eastern Avenue. It was moved in 1850 to the location pictured here, roughly where Exchange Street now meets Main Street. This photograph was taken in 1867 from Irving Street, looking toward Main Street.

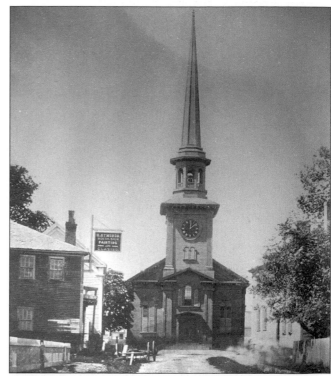

The First Church Congregational was destroyed by the gale of September 1869.

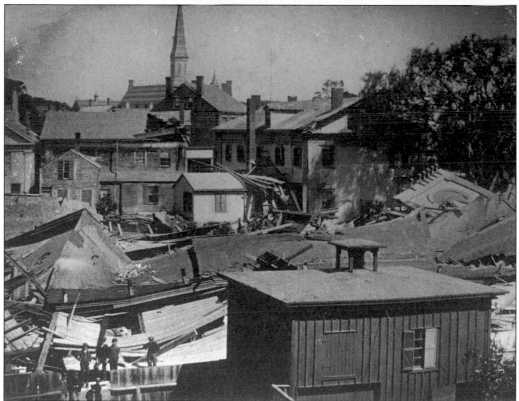

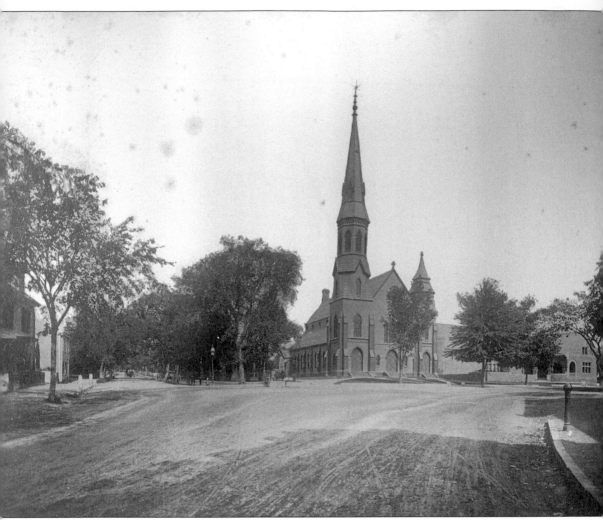

The Baptist church at the corner of Salem and Main Streets is seen here, *c.* 1885. By 1890, the present Baptist church edifice was under construction at this site.

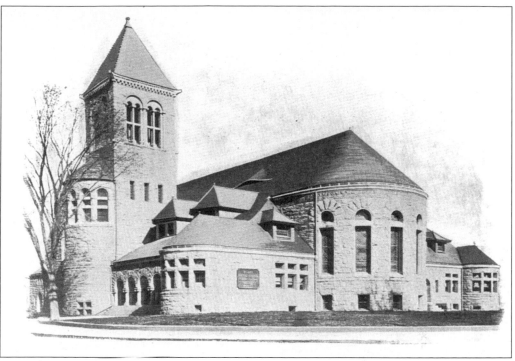

Erected in 1890 through the beneficence of Elisha Converse, the First Baptist Church, located on the corner of Main and Salem Streets, replaced the earlier church on the same site.

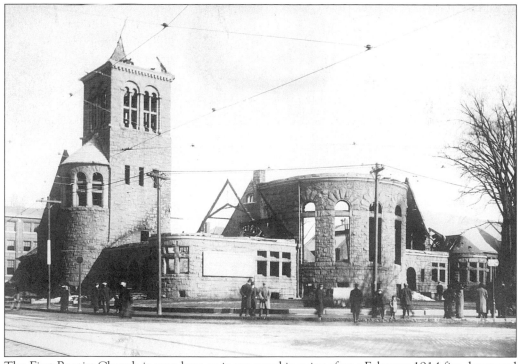

The First Baptist Church is seen here as it appeared in ruins after a February 1914 fire destroyed large parts of the building. It was rebuilt the following year and essentially remains the same.

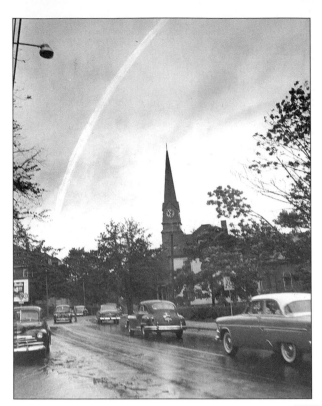

The Immaculate Conception Church can be seen in the distance in this view of Pleasant Street, looking east toward Malden. The first Catholic church in Malden, it was erected in 1855 when the land was then a part of Medford. This photograph showing a rainbow was taken in September 1954, after hurricane Edna.

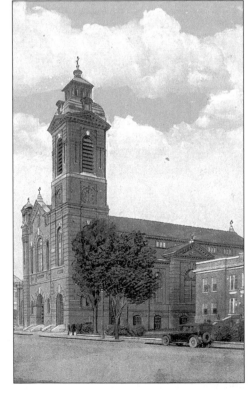

Sacred Hearts Church, the second Catholic parish in Malden, was built in 1892 by Fr. Thomas Shahan. Shahan was called the "Church Builder" because of the many churches he built in the diocese. This is said to be his last and greatest achievement.

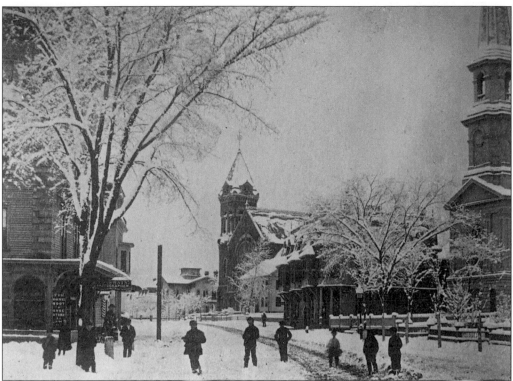

Pleasant Street is seen in the winter of 1875. Prominent are both the old and new Methodist churches, which seemingly dominate Pleasant Street. The old church, which burned in 1875, was later used as an auction house and by 1899, as offices for the Malden Evening Mail.

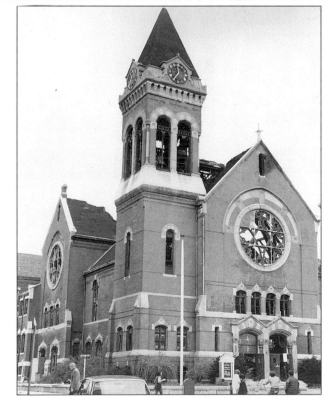

The Centre Methodist Church appears in ruins after a May 1971 fire, which was set by vandals. A new church was constructed on the site at the corner of Pleasant and Washington Streets.

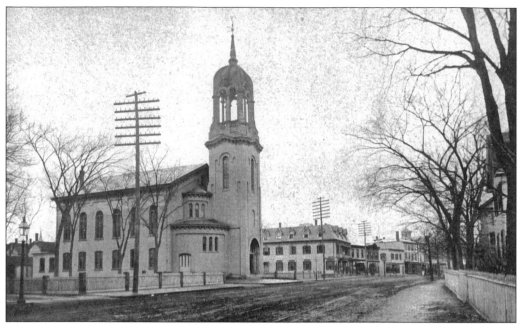

The First Parish Universalist Church was built by the Malden Church in 1802. Prior to the construction of the Town House in 1857, town meetings, traveling shows, and lectures were held here. The Malden Lyceum met here, as did the town's militia company, the Washington Guards. Seen north of the church is Lewis's Block, which contains the New England Oyster House, Herkloss's Bakery, and a continuous line of stores to Pleasant Street.

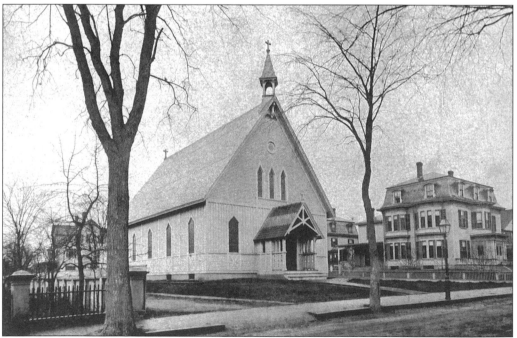

The original St. Paul's Episcopal Church is seen here on Washington Street near the corner of Florence Street. A new stone church designed by Ralph Adams Cram was added in 1902. This building is now used as a parish hall.

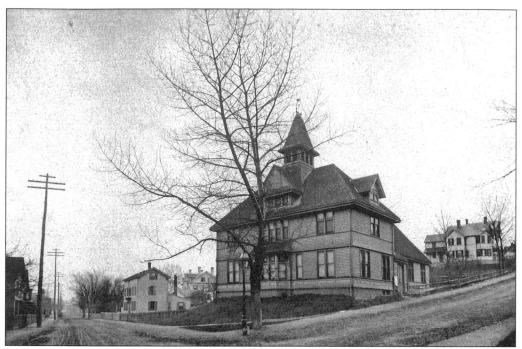

The Unitarian chapel was built in 1878 at the corner of Eastern and Hillside Avenues on land donated by David Morey. This building later was used as Emmanuel Baptist Church and in the 1980s, it was replaced by a newer structure.

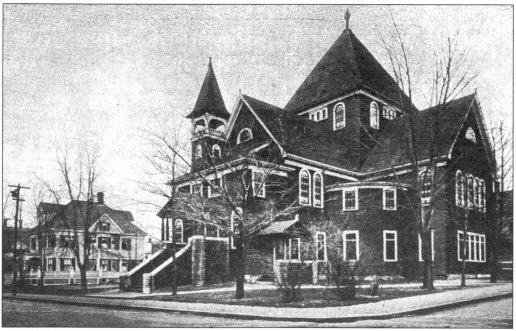

The Robinson Methodist Episcopal Church was built in 1888 at the corner of Boston and Fairmont Streets in the Belmont Hill section of the city. As its membership decreased, the church joined with the Centre Methodist Church to form the Centre United Methodist Church at the location of the latter, on Pleasant Street.

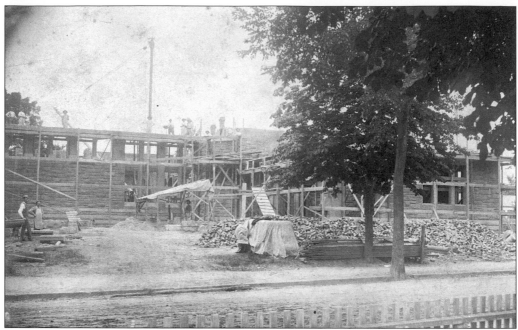

Construction of the Converse Memorial Building was captured in this August 1884 photograph. Designed by Henry Hobson Richardson, the structure was built to house the Malden Public Library on a site selected by Frederick Law Olmsted. It was dedicated in 1885 in memory of Frank Eugene Converse, who was slain in a robbery of the First National Bank of Malden and was the son of Malden's first mayor, Elisha Converse.

ENTERTAINMENT

FOR THE BENEFIT OF THE

PUBLIC LIBRARY

AT THE

UNITARIAN CHAPEL,

December 11th, at 7.30 o'clock, P. M.

Tickets, 50 cents. 1879

[OVER.]

This 1879 ticket to an "Entertainment" represents one of the first fund-raisers to bequest the Malden Public Library. The library was founded with the bequest of $5,000 from John Gardner in 1879 and was housed in the Malden Town Hall until the Converse Memorial Building was built in 1885.

Four

NEIGHBORHOODS AND STREET SCENES

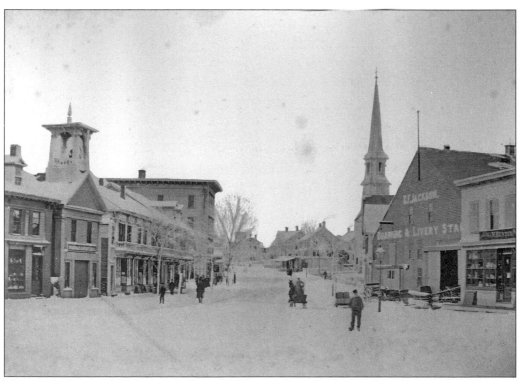

The original central firehouse, built in 1864, is seen on the left in this photograph of Central Square, taken in 1867, looking west from Main Street along Pleasant Street. To the right is Jackson's Livery Stable, and beyond that is the steeple of the Centre Methodist Church.

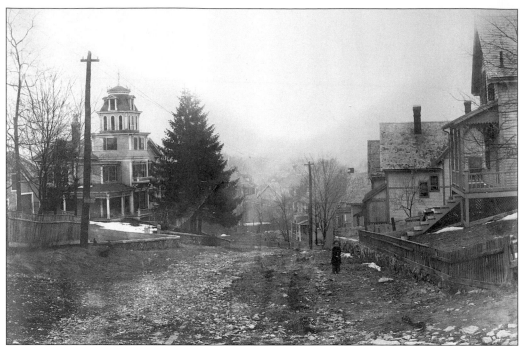

Paving and sidewalk construction had not begun when this photograph of Montrose Street was taken, looking south from Tremont Street, *c.* 1906.

Winthrop Street in the Belmont Hill section shows typical single-family homes constructed in Malden during the Victorian era.

The early development of Maplewood Highlands is depicted in this view of Williams Street. Williams is one of a number of streets in this section believed to have been developed from Native American trails that networked this area.

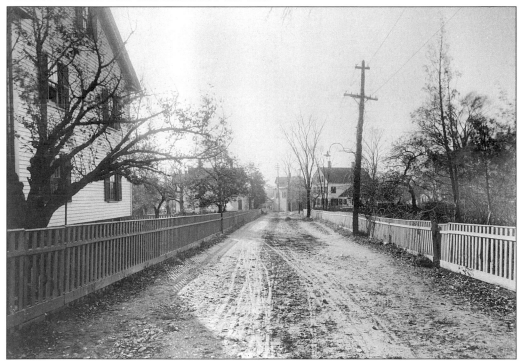

This photograph of Clark Street was taken looking south toward Salem Street. Originally, the street was lined with Mrs. Clark's orchards.

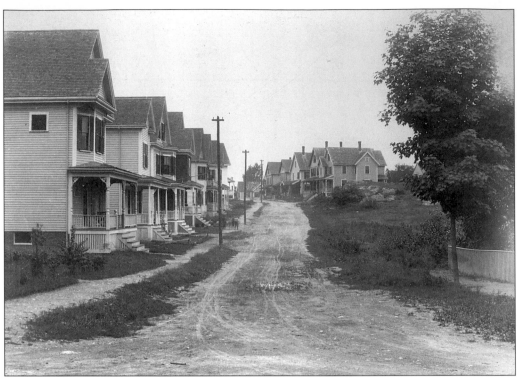

Almont Street in Suffolk Square is seen here from Bryant Street. Taken looking west, this photograph shows a typical view of neighborhood homes. The undeveloped area on the right later became home to the Malden Hebrew School.

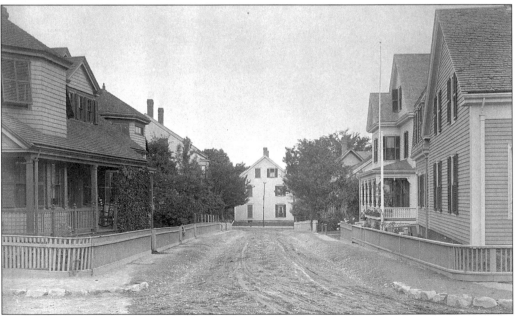

This photograph of Spring Street was taken from the corner of Sprague Street in 1897. It shows the many noteworthy houses of varying architectural styles in this area—a neighborhood that maintains its historical characteristic today.

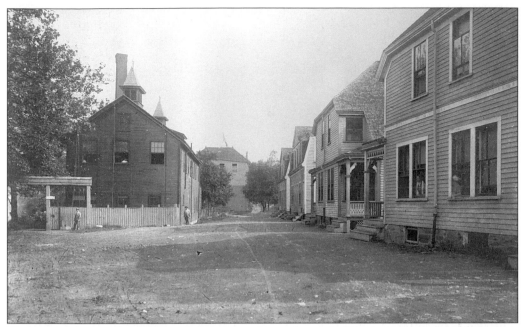

The rear of the wooden Malden Armory is visible at the end of Barrett Lane in this photograph taken looking north in 1907. On the left is Barrett's Dye House.

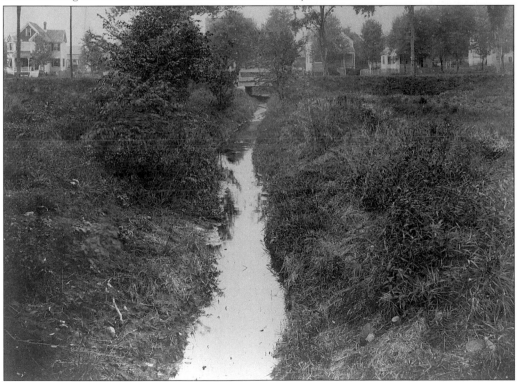

The Linden Brook was a low, marshy area before it was developed in the 1880s by the Linden Land Company. This photograph of the brook was taken looking south from Springdale Street in Linden.

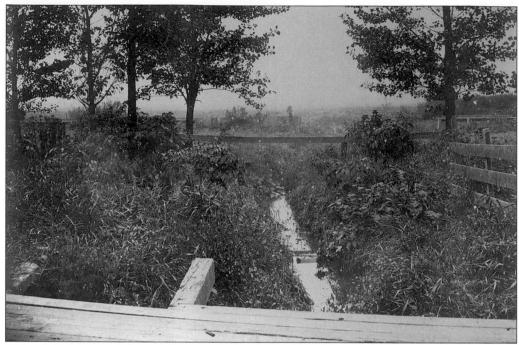

This photograph of the Linden Brook was taken looking south from Claremont Street in Linden.

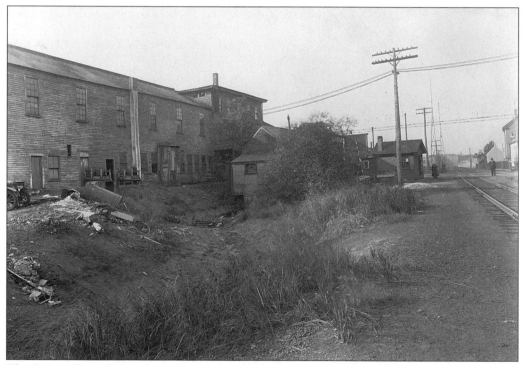

The Saugus Branch Brook is seen in this 1927 photograph, taken looking southwest from a point on the railroad about 150 feet east of Main Street. The brook was originally called Harvell's Brook by early Malden settlers. It still exists today, buried from view in a culvert.

Beltran Street is seen at the foot of Las Casas Street in this view taken in July 1897. The names Beltran and Las Casas recall the name of William Beltran de Las Casas, who owned much of the land in this area.

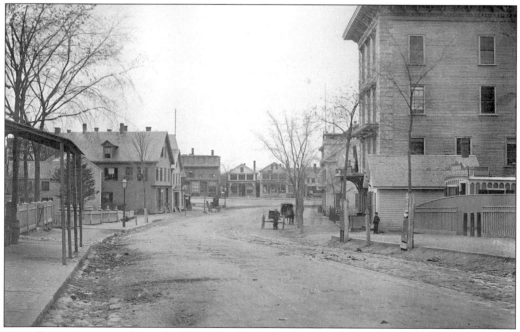

Main Street is seen at the end of Pleasant Street in this view from 1869. In the foreground on the right side of Pleasant Street near the present-day Middlesex Street is Bailey's Block, Shiloh's Barbershop, and E.C. Swain's photography car.

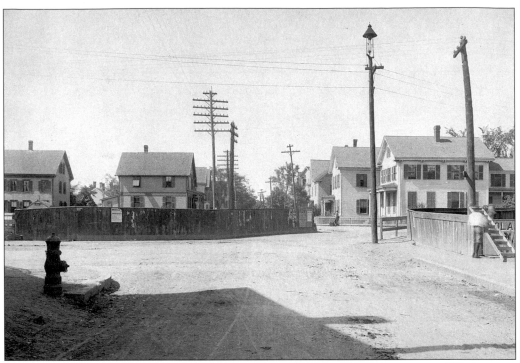

This 1897 photograph of Clifton Street was taken looking west from the corner of Washington Street. Many of the houses still exist today, although slightly altered.

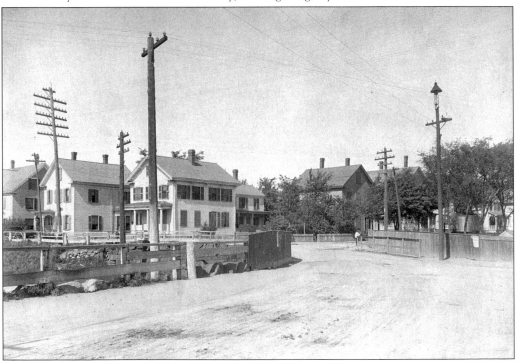

Another view of Clifton Street was taken looking north from Washington Street in 1897. This intersection, largely residential today, once boasted a pharmacy and a cobbler's shop.

This pond on Clifton Street was created by flooding from the Spot Pond Brook, also known as the Three Mile Brook. It was located roughly in the vicinity of Beltran Street. Another pond on Clifton Street was located at Coytemore Lea and was sometimes called Benson's Pond.

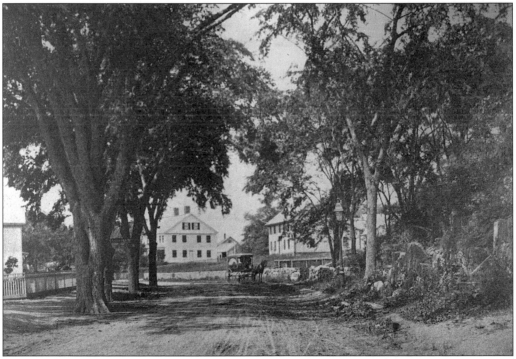

The stately Faulkner elms are seen here lining Salem Street, as it rounds the bend westward toward Pierce Street. The Faulkner Farmhouse, on the right, later became the site of the Faulkner School. It is currently the site of the Salem Towers apartment complex.

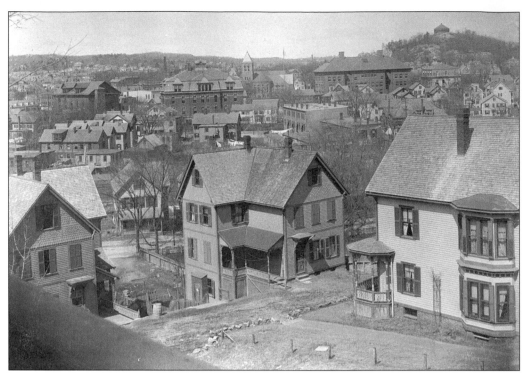

This view of Malden Square from Hillside Avenue and Garfield Terrace was taken in 1899. The houses in the foreground are located on Garfield Terrace and can still be seen today. Visible in the background are the city hall, Centre Grammar School, the First Baptist Church with its tower, and the high school.

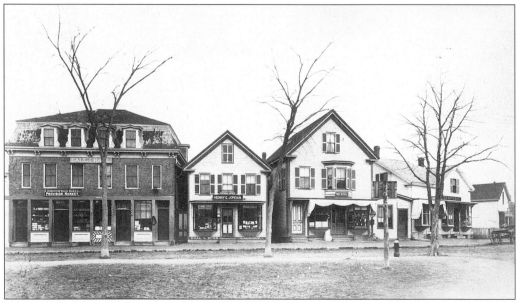

Salem Hall, shown in this view of the north side of Salem Street in Maplewood Square opposite the Pythian building, was demolished in 1934 and was replaced with the present block of stores. The wooden buildings at the right are still standing and in use.

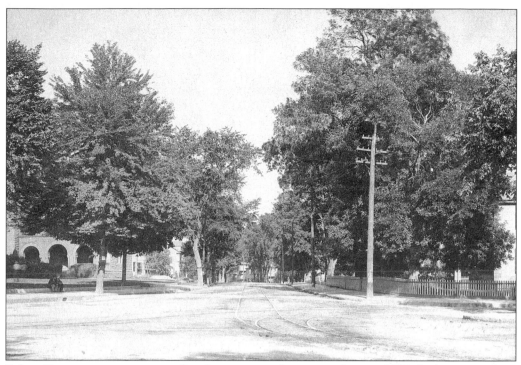

Salem Street appears as a tree-lined avenue in this view taken in 1897, looking east from Converse Square. The Converse Memorial Building is on the left, and beyond it the Davenport Estate is seen under construction.

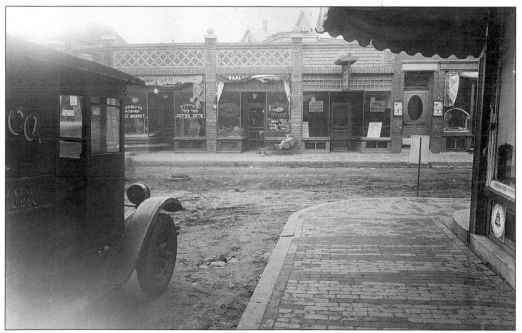

The easterly side of Bryant Street is seen in this 1930 view from Grape Street. The photograph shows a number of stores on Bryant Street. During urban renewal of the Suffolk Square area, the buildings were demolished.

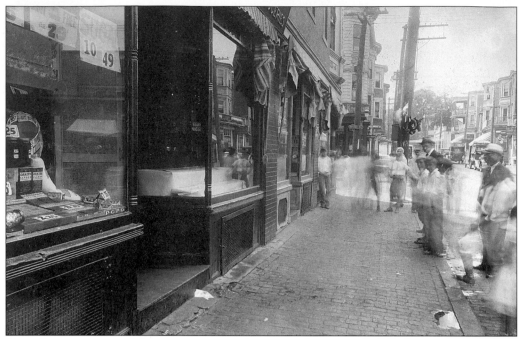

Cross Street was one of the main streets in the section known as Suffolk Square, the center of the Jewish community in Malden. This photograph presents a view of the many small businesses that served the neighborhood.

The intersection of High Street on the left and Hancock Street on the right is seen in this view of Cross Street in March 1930. The Belmont School sits at the top of the hill on the left. Note the trolley tracks on Cross Street and the clock tower on the Belmont School.

A view of the corner of Almont and Franklin Streets in March 1931 shows Eastern Avenue beyond the Malden Knitting Mills, which are on the left.

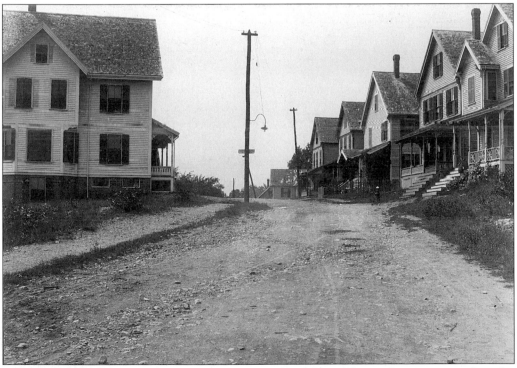

This photograph taken near 41 Almont Street shows how Almont Street appeared at the beginning of the 20th century. Many of these houses still stand today. Most were constructed at the turn of the century as affordable middle-class housing.

This view, taken looking south toward Everett, shows Henry Street from its intersection with Boylston Street. At the time the photograph was taken, the streets in this area were being laid out. As of 1999, the houses at each corner of Boylston Street were still in existence.

Malden City Hall and the Odd Fellows Block are seen in this view from 1885. The old city hall was built in 1857 by Jonathan Clark and was originally called the Town House. It originally held the high school and a dry goods store on the first floor, town offices on the second floor, and the Mount Vernon Lodge of Masons on the third floor. To its left is the Odd Fellows Block, in the area of the present-day Medford Bank.

This photograph of Malden Square, again from 1885, shows the Waite Block and the Varnick Building. The Waite Block on the right was built in 1854 and is the oldest brick structure in Malden today. The building originally followed the line of Pleasant Street, but the left portion was later built out. To the extreme left is the Varnick Building, better known to many as the home of the Granada Theatre.

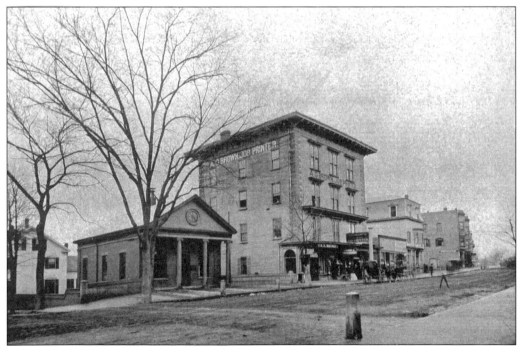

This view of Pleasant Street at Middlesex Street shows the First National Bank, built in 1851, on the left. Bailey's Block, the taller building, was built during the Civil War on the site formerly occupied by the Centre Grammar School.

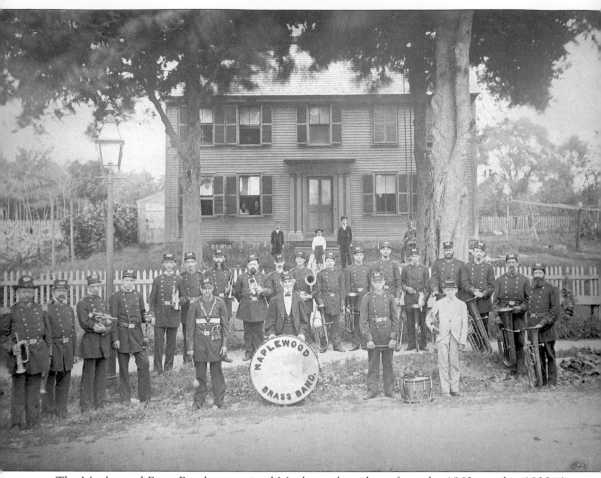

The Maplewood Brass Band entertained Maplewood residents from the 1860s until *c.* 1900. A bandstand was located in Maplewood Square where the Pythian Building now stands. Bandmaster Spofford and the group are pictured in front of what appears to be Waite's Tavern, which was situated on Salem Street.

Unrecognizable today but for the street sign, the southeast corner of Maplewood Square is seen here c. 1900. This building stood at the corner of Maplewood and Salem Streets. Originally a house, it had been converted into a restaurant by the time this photograph was taken.

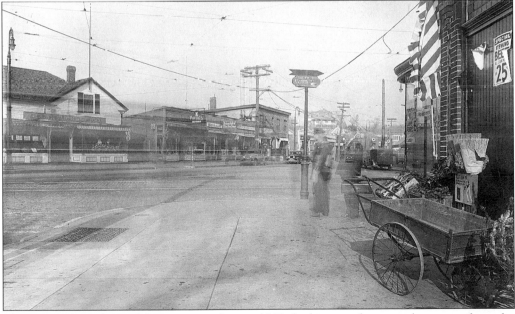

This view of Maplewood Square was taken in 1930, looking north across the square from the southeast corner of Salem and Maplewood Streets. The old house in the earlier photograph had been removed, and the present single-story commercial block had been built. Note that the wooden buildings on the north side of the square still stand today, housing a variety of stores.

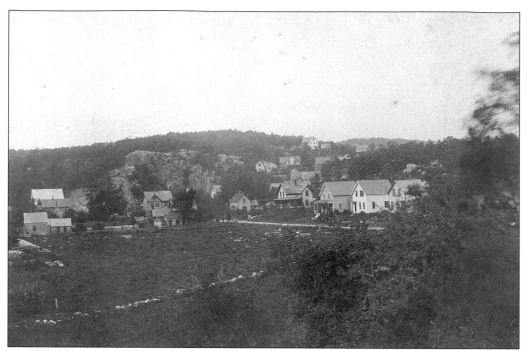

The area of Maplewood called High Rock is seen in a summer view taken *c.* 1890. Granite Street is visible on the right. The rocky field in the center is now Trafton Park.

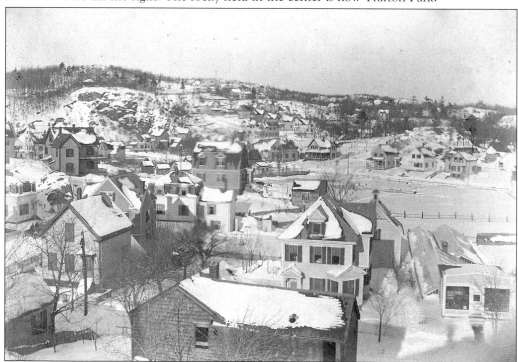

This photograph of High Rock, taken one winter *c.* 1890, shows homes that were rapidly being developed in the area at the time. Note Lebanon Street running across the foreground and the greenhouses at the lower right-hand corner.

Five

TRANSPORTATION

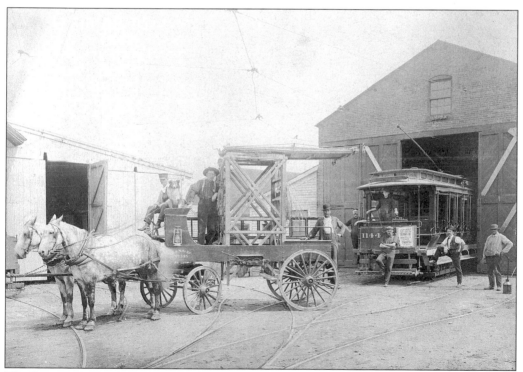

The Boston & Northern Street Railway's "tower wagon" No. 135 and open car No. 144 are shown at the carbarns located on the southeast corner of Broadway and Salem Street, *c.* 1908. Notice the poster on the trolley advertising a "4 day carnival" at Salem Willows. The tower wagon was used to string and repair overhead wires. After horse-drawn cars were retired, motortrucks performed the same work until the street railway service ended in the 1930s.

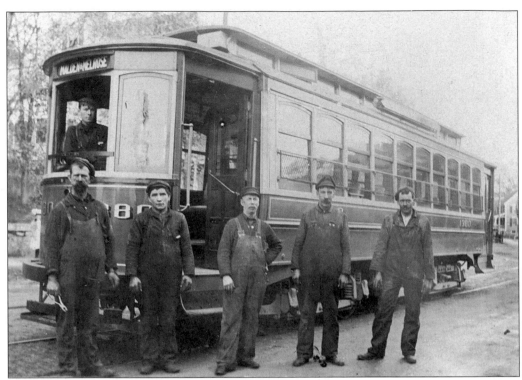

The No. 1380 car of the Boston & Northern Street Railway is pictured somewhere on Main Street, c. 1908. This car was a single-end car (meaning its controls were only at one end) used exclusively on the Melrose Highlands–Brattle Street (Scollay Square) line. Colors used on these cars were white and pencil yellow with silver and black striping.

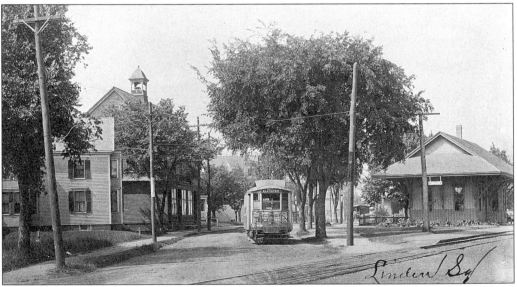

This Boston Elevated Railway semiconvertible car arrives at the end of the Sullivan Square–Linden Square line on Lynn Street, c. 1906. Linden Station on the Saugus Branch railroad is on the right. The car has just arrived from Boston via the Broadway and Eastern Avenue Extension, as it was then called.

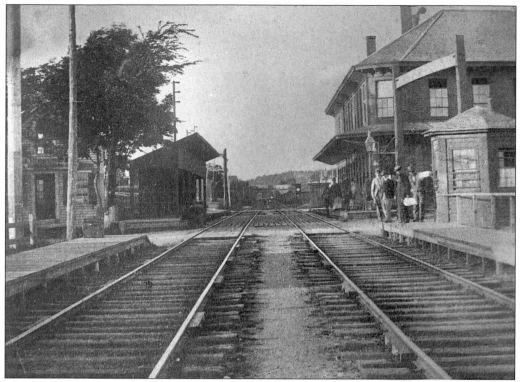

The first Boston & Maine railroad station in Malden is shown in 1867 in a view from the tracks, looking north from Pleasant Street. Built in 1845 on the east side of the tracks, the station was razed in 1872. The photograph was taken before the alteration of Summer Street and the construction of the later railroad station.

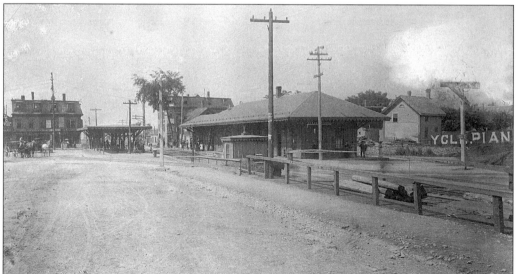

This photograph of the Boston & Maine grade crossing at Summer Street, taken looking south in 1880, shows the second railroad station, built in 1871. Summer Street has since been altered to run parallel to the tracks and no longer crosses them, as it does in this view. This station was razed in 1892 when Summer Street was extended along its present route to Pleasant Street.

The Summer Street grade crossing at Florence Street, as seen in 1885, shows that both Florence and Summer Streets crossed the railroad tracks at grade level.

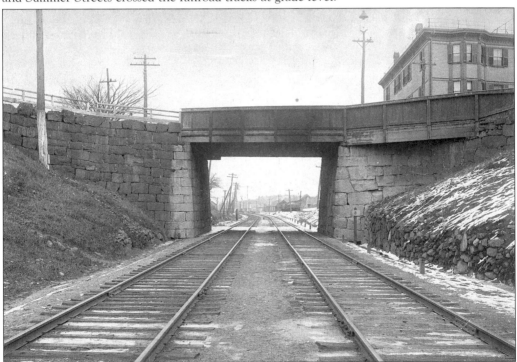

A traveler standing on the Malden Station platform looking north would have had this view of the Boston & Maine Railroad tracks and the Clifton Street bridge in 1897. Later, this bridge was replaced with an iron trestle, which served until 1993, when the present concrete bridge was constructed.

The second Malden Station on the western division of the Boston & Maine Railroad was a busy place, as can be seen in this photograph of early commuters waiting for the morning train. This station served Malden until 1892, when a new train station was built on Summer Street.

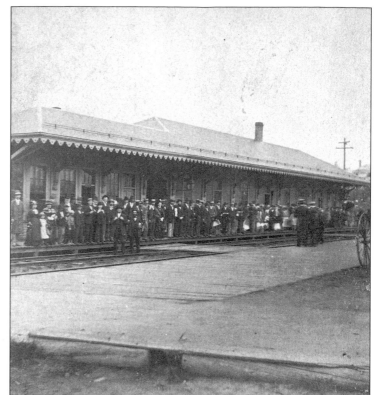

The former Oak Grove depot on the Boston & Maine's western division is shown on March 19, 1974, one day before its demolition to make way for the present Oak Grove MBTA Orange Line station. At the time of demolition, the depot was occupied by an antique dealer.

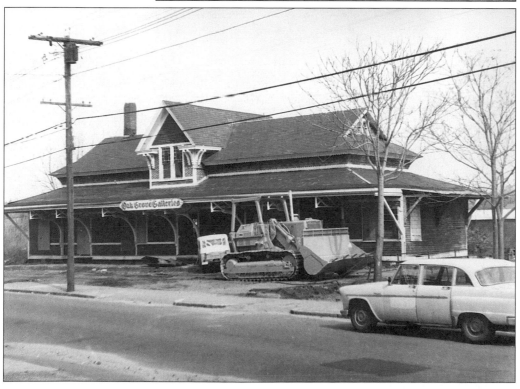

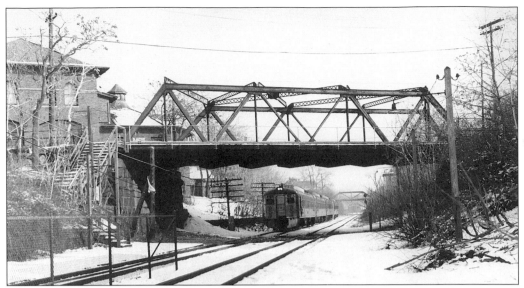

The Mountain Avenue Bridge is seen at the northern end of Malden Station on the Boston & Maine's western division railroad. Note the wooden stairway at the side of the bridge and the end of the passenger platform, which allowed access to the station from Clifton Street. In this photograph, taken on March 12, 1971, a train of Budd self-propelled rail diesel cars approaches the station from Melrose. The bridge was demolished in 1993.

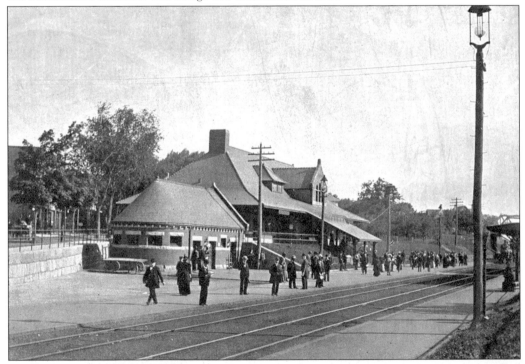

The Boston & Maine Railroad western division station on Summer Street was commonly called Malden Station. It was a typical large station with a passenger waiting room, ticket offices, and Railway Express offices. Closed to passenger service in 1957, it later was converted to a function hall. It currently houses a restaurant.

Six

BUSINESSES

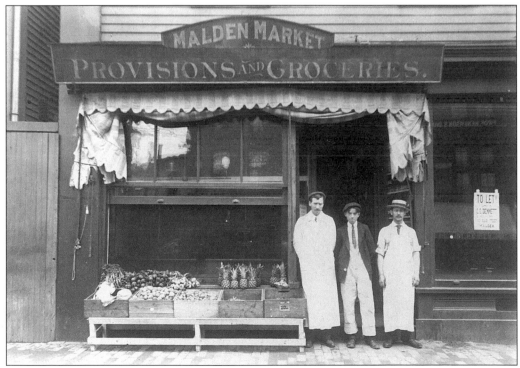

The Malden Market was located on Main Street in the vicinity of Malden Centre *c*. 1900. The gentleman in the straw hat is Walter L. Fuller.

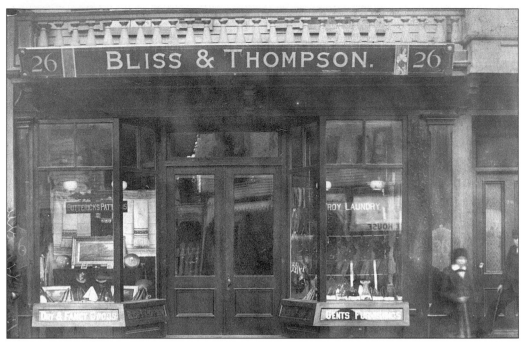

The Bliss & Thompson dry goods store, located at 26 Pleasant Street, was founded by Alvin E. Bliss and Harvey L. Thompson in 1881 and sold fancy dry goods and men's furnishings. By 1886, Bliss had sold the business and had become instrumental in establishing the Malden Electric Light Company, which brought electricity to Malden.

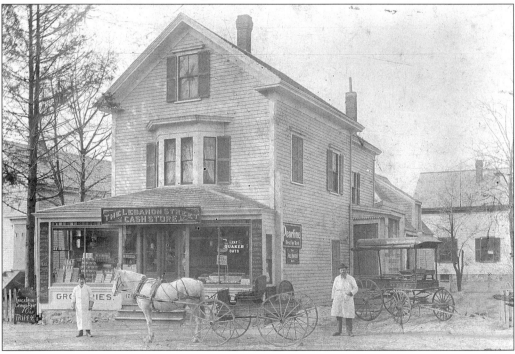

The Lebanon Street Cash Store is seen in this *c.* 1900 view. The store is typical of the many small markets in Maplewood and throughout the city.

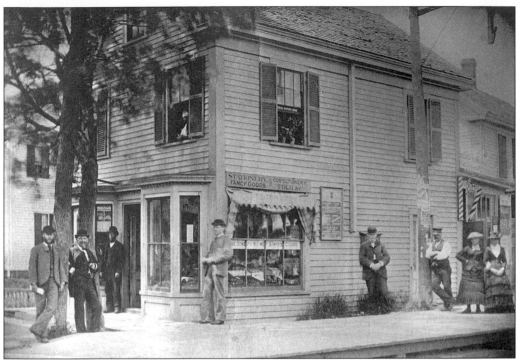

James Howard's shoe shop is seen in this photograph from 1880. Built in 1857 on Pleasant Street, the shop was moved to Summer Street in 1893.

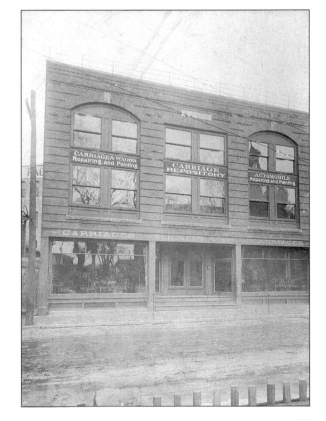

The W.B. Keen & Son Carriage Shop is seen here c. 1900. This Malden firm built carriages for European royalty and the wealthy. After the passing of the horse-and-buggy days, the firm survived well into the 1950s by performing auto body repairs.

William Barrett's Malden Dye House, later known as Barrett's Dye Mills, was opened in 1804 and was the largest employer in the town during the first half of the 19th century. The dye house, shown here as it appeared in 1817, was located on the present Ramsdell Road, behind the post office and armory.

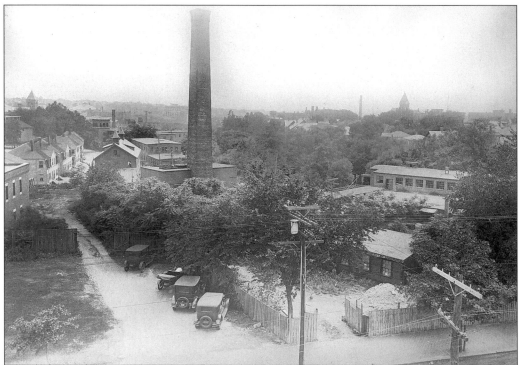

Barrett's Dye Mills, opposite Coytmore Lea Park, was known as the Turkey Red Works when it was owned by John Cochrane. It was being demolished at the time this photograph was taken in 1927. The site currently serves as the parking lot behind the Mountain Avenue post office.

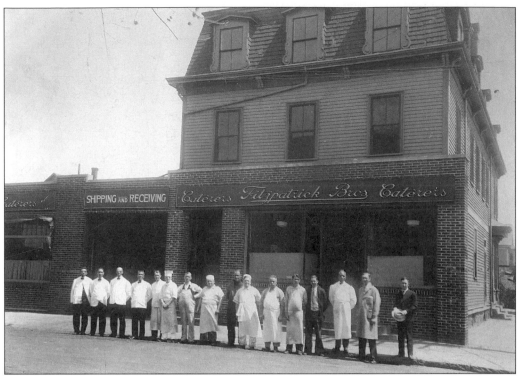

Fitzpatrick Brothers Caterers shows off its cooking staff in front of the premises at 342 Pearl Street at the corner of Medford Street. The company started in the 1920s and lasted until the 1970s. Howard Fitzpatrick (the other brother was Richard) served as sheriff of Middlesex County from 1945 to 1970.

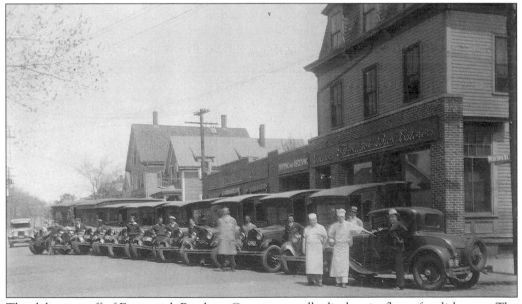

The delivery staff of Fitzpatrick Brothers Caterers proudly displays its fleet of stylish vans. The building still stands and was used as a central kitchen food facility for the public schools until the early 1990s. It now houses a commercial bakery.

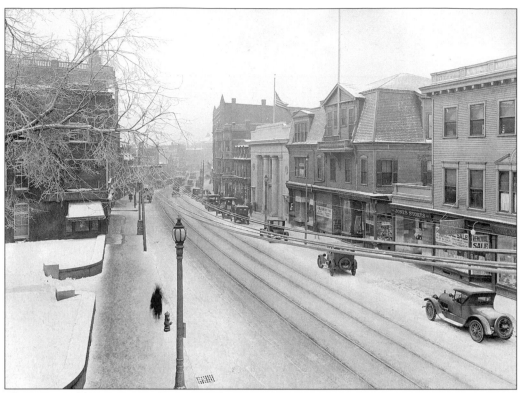

The new Malden Trust Building and the Grand Army Hall are on the right in this view of Pleasant Street, looking east in the winter of 1924.

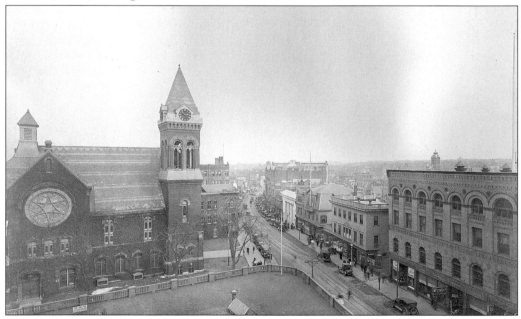

This photograph of Pleasant Street taken from the roof of the Auditorium Theatre shows the Centre Methodist Church on the left and the Masonic Building on the right. Note that Washington Street does not yet cut through to Exchange Street.

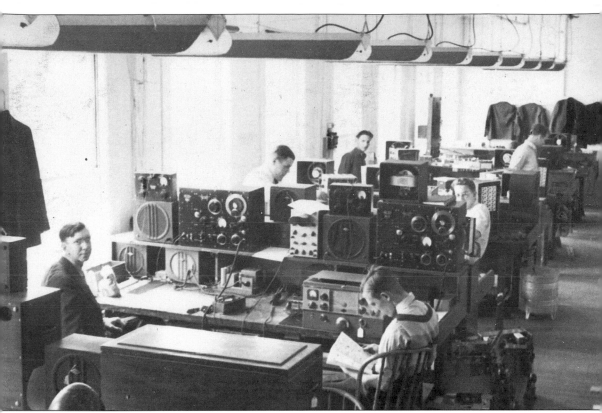

This is how the National Radio Company's testing laboratories appeared between 1937 and 1941. By 1949, the National Radio Company had produced a 10-inch television set and television equipment for scientists, commerce, and amateurs worldwide.

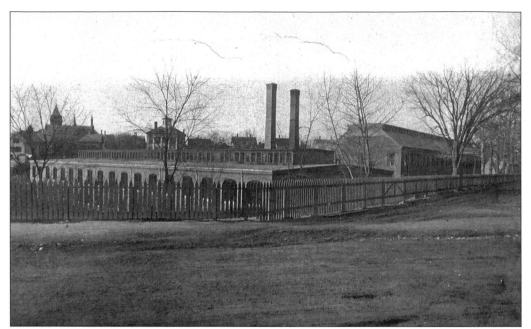

In 1847, John Cochrane came to Malden and established a printing and dyeing business on the site of Thomas Coytmore's old mill on Mountain Avenue. By 1857, the Cochrane Manufacturing Company was established on the site of Barrett's Dye Mills. The company began to manufacture carpet at this time and continued into the early 1900s. It also manufactured carpets from a mill in Dedham. These mills in Malden were located near the present post office.

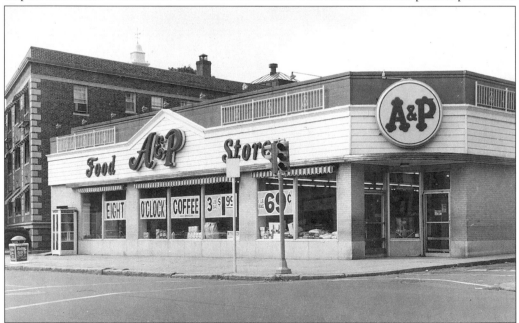

The Great Atlantic & Pacific Tea Company, better known as the A&P, became a familiar sight in the 1950s. One of the first supermarkets, it still maintained a local flavor. This store at the corner of Pleasant Street and Pleasant Street Park is shown as it looked in 1971. The building remains, with new occupants. The A&P also had a store in Maplewood Square.

Seven

THE BOSTON RUBBER SHOE COMPANY

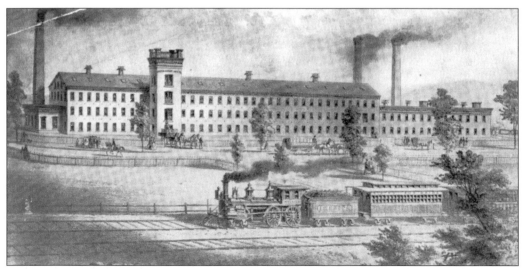

This *c.* 1853 engraving of the first rubber factory erected in Malden shows the original plant of the Boston Rubber Shoe Company. The factory was located on what is today Commercial Street, roughly near Lamson & Davis Hardware. It was destroyed by fire in 1875.

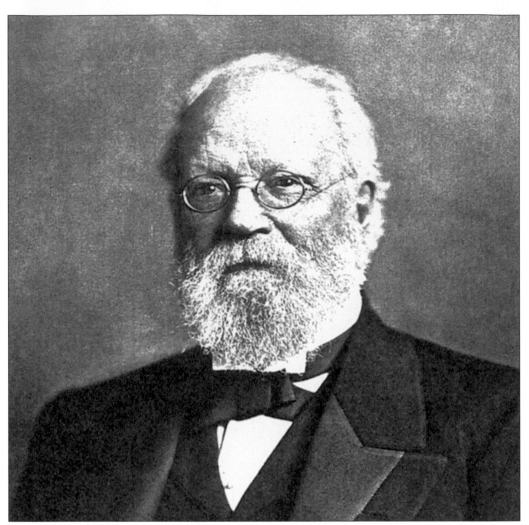

Elisha S. Converse (1820–1904) was elected the first mayor of Malden in 1882 and was a founder and manager of the Boston Rubber Shoe Company. He came to Malden in 1850 and resided on Main Street. His estate covered the entire area bounded by Main Street, Perkins Avenue, Bell Rock Street, and Wyllis Avenue. From 1849 to 1853, Converse was partners with John Robson in an early rubber enterprise called Converse & Robson. In 1853, Converse was elected treasurer and manager of the Malden Manufacturing Company, the successor to the Edgeworth Rubber Company, an unsuccessful business begun in 1850. By 1855, Malden Manufacturing was incorporated as the Boston Rubber Shoe Company and erected a factory in Edgeworth. In 1875, the factory was enlarged and in 1882, a second factory built on Washington Street in Melrose just over the Malden line. The Boston Rubber Shoe Company was Malden's largest industry and employer from the 1870s to the early 1920s. It manufactured rubber boots and shoes under the trade name Hub Mark. It later became a subsidiary of the United States Rubber Company. Although his surname is the same, Elisha Converse had no connection with the Converse Rubber Company. In 1909, Marquis M. Converse began the Converse Rubber Shoe Company, which also built a factory in Edgeworth and conducted business here until the 1970s. The photographs that follow were taken by E.C. Swain and are a part of the Boston Rubber Shoe Company collection, now in the possession of the Malden Historical Society.

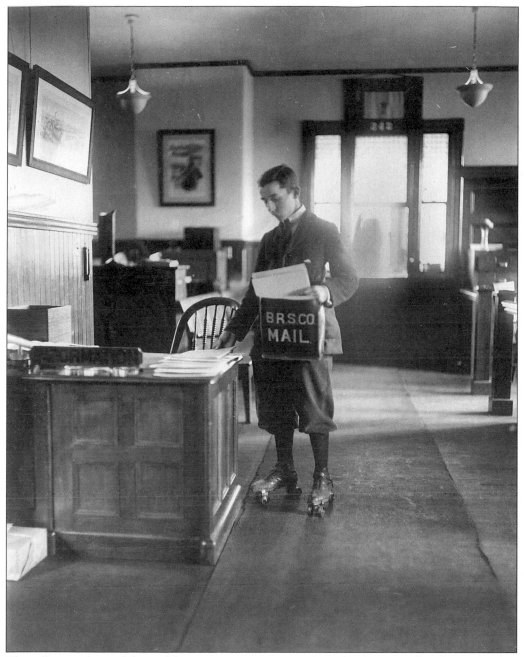

The office mail was delivered by young messengers, such as this boy on roller skates. With a comprised floor area of 16 acres in both the Malden and Melrose factories, it is no wonder roller skates were necessary.

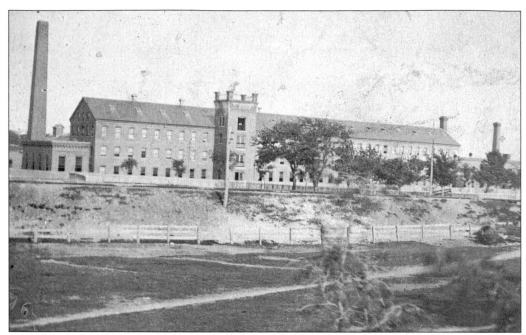

The Boston Rubber Shoe Company plant No. 1 was located in Edgeworth on what is today Commercial Street. It was destroyed by fire in 1875.

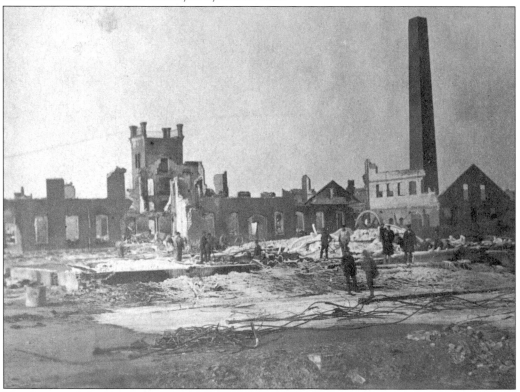

The factory of the Boston Rubber Shoe Company suffered a catastrophic fire on November 29, 1875, as seen in this view from the company's yard.

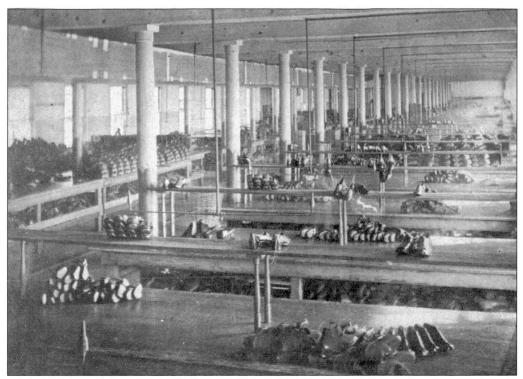

One of the many specialized facilities contained within the enormous factory was the old packing room of the rubber company. This is where the products were put together for shipment to customers worldwide.

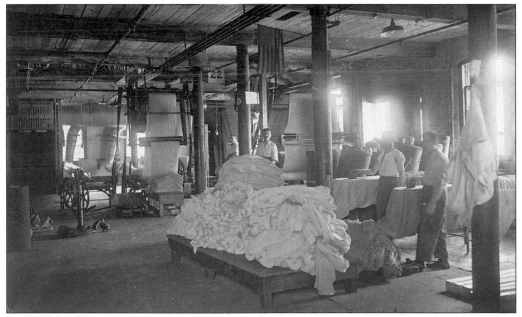

An interior view of the factory shows the conditions under which the employees worked. This appears to be the extruding room, where rubber was fabricated into thin sheets that were later used to make the various rubber products.

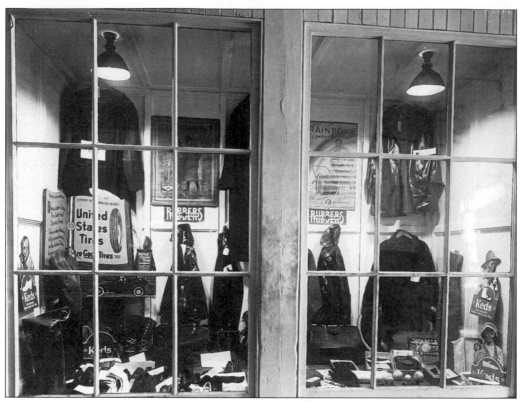

The company was proud of its many products, as shown in this display at the factory. At the time this photograph was taken, the Boston Rubber Shoe Company was a subsidiary of the United States Rubber Company. Therefore, not all the goods displayed were made in Malden, although the boots and shoes were.

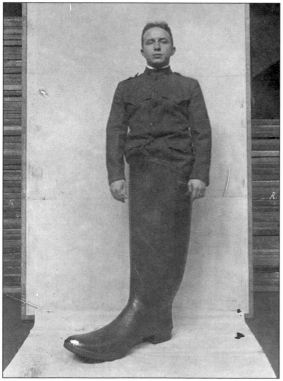

This eye-catching promotional product display was entitled, "He gets a boot from his job."

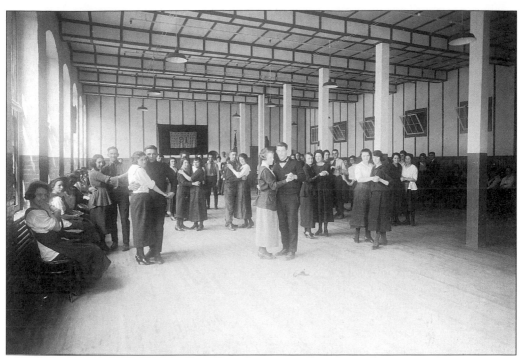

Factory employees organized this party at the plant. The rubber factory workers also fielded a baseball team, put out their own newspaper, and held social events such as this one.

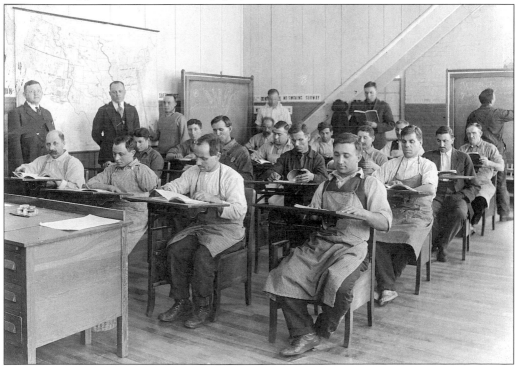

Immigrant workers attended company-sponsored Americanization classes at the plant. Many were Italian immigrants who resided near the factory in Edgeworth.

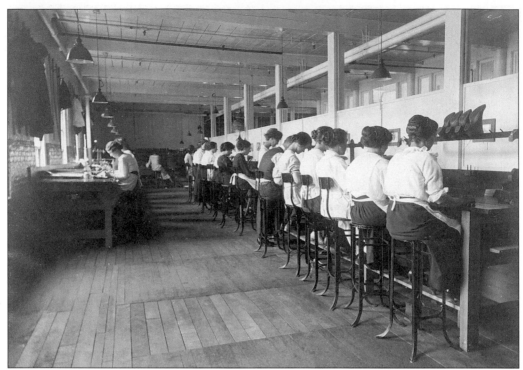

Women worked on parts of the assembly line, as seen here *c.* 1918. This practice continued until the factory closed. This may have been a gluing line, where the heels and buckles were glued to the unfinished shoes.

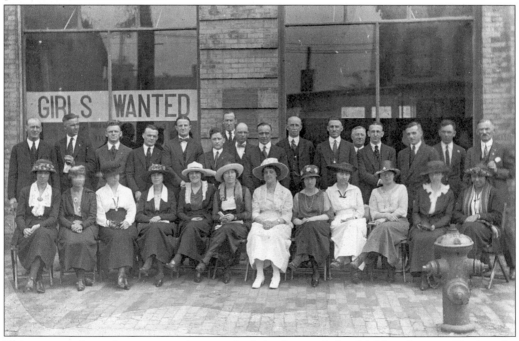

This group of employees was photographed in front of the Malden factory. Notice the advertisement for women workers.

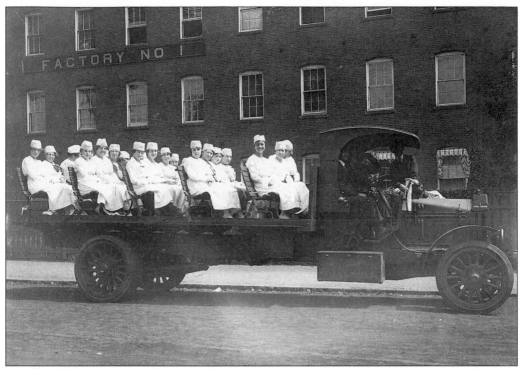

Boston Rubber Shoe Company employees get ready to do their part representing the company in a parade.

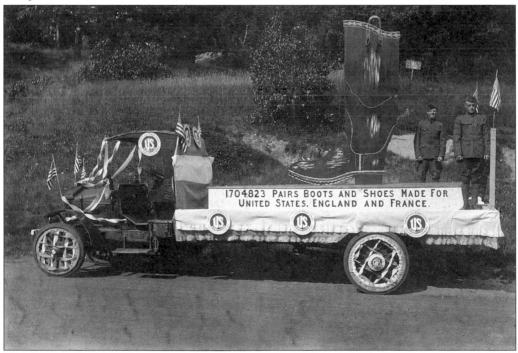

1704823 PAIRS BOOTS AND SHOES MADE FOR UNITED STATES, ENGLAND AND FRANCE.

Production at the plant during World War I was a proud achievement worth advertising, as evidenced by this parade vehicle.

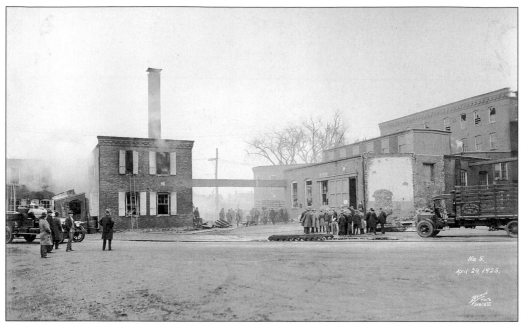

Another fire damaged the factory on April 29, 1925, as seen in this photograph.

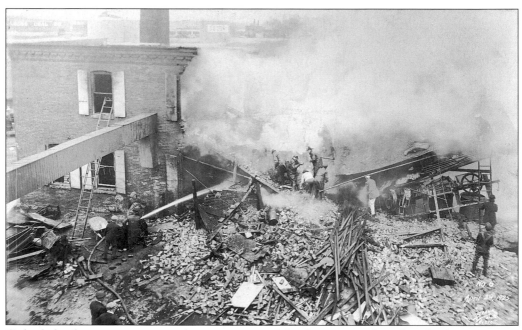

Only skeletal structures remained in some parts of the factory complex after the fire.

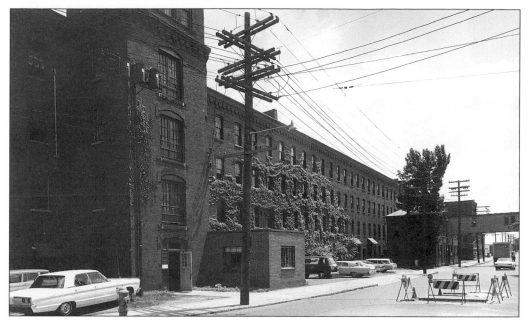

A 1960s view shows the factory as it appeared before demolition for urban renewal of Commercial Street. In its later years, the factory building was home to various businesses; notable among them was the Vogue Doll Company.

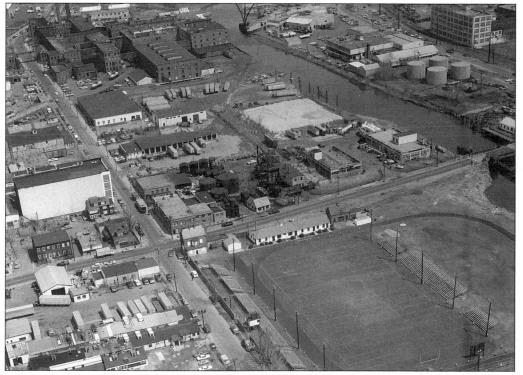

An aerial view of the rubber factories along Commercial Street and the Malden River shows Brother Gilbert Stadium in the right foreground, at the intersection of Commercial and Medford Streets.

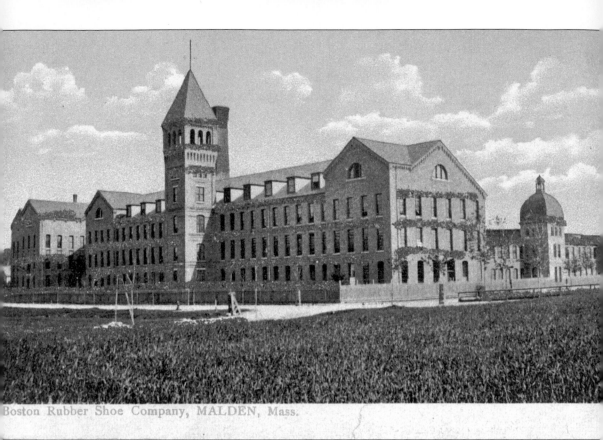

Boston Rubber Shoe Company, MALDEN, Mass.

The Boston Rubber Shoe Company built a second factory on Washington Street in Melrose, just over the Malden line. The factory still stands north of the Oak Grove MBTA station.

Eight
BANKING

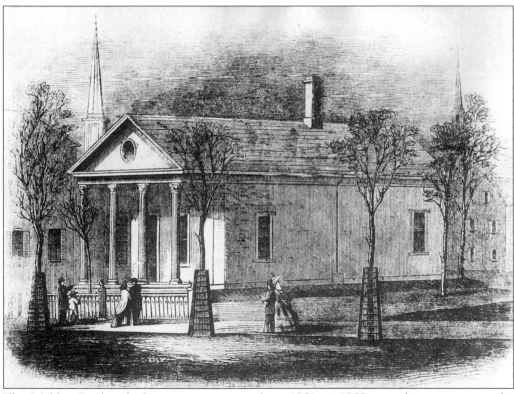

The Malden Bank, which was in operation from 1851 to 1857, was the successor to the Agricultural and Mechanic Bank. This engraving shows how it appeared in 1864 on Pleasant Street at the corner of Middlesex Street. Timothy Bailey was its first president. Malden Mayor Elisha Converse also served as president of this institution. The Malden Bank was succeeded by the First National Bank which, in turn, was absorbed by the Malden Trust Company.

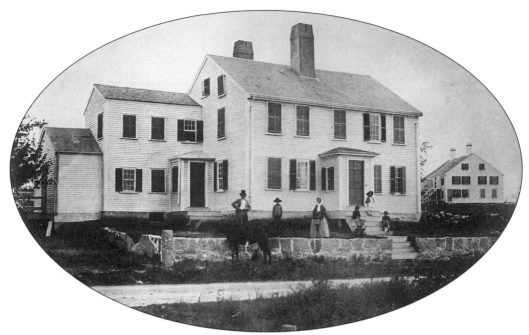

Malden's first bank, the Malden Agricultural and Mechanics Association, was located in the home of Timothy Bailey on Madison Street (1833–1851). Bailey was a tinker and a well-respected member of the community. He also produced pewter ware with his nephew James Putnam for a time. The house passed through various hands and was demolished in the early 1990s.

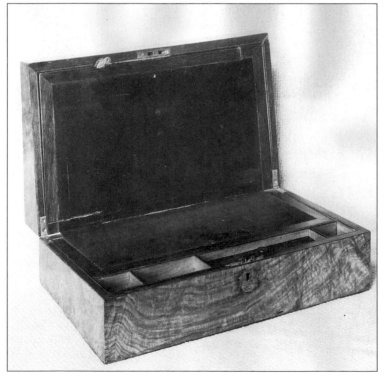

The original bank box used by Timothy Bailey actually consisted of this wooden writing box, which is currently in the possession of Eastern Bank. Eastern evolved from Timothy Bailey's original bank.

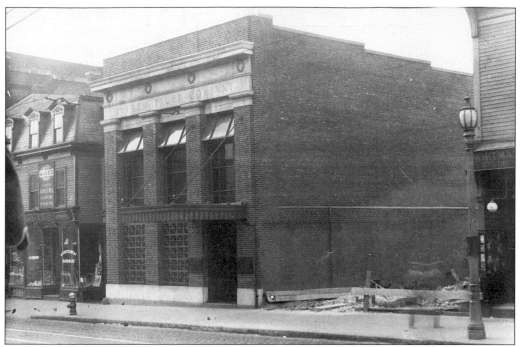

In 1923, the Malden Trust Company replaced its older building on Pleasant Street with a new structure. This photograph shows the old building on July 18, 1923. Adjacent to Malden Trust is the Whitman Studio, on the right, a longtime Malden photographic company.

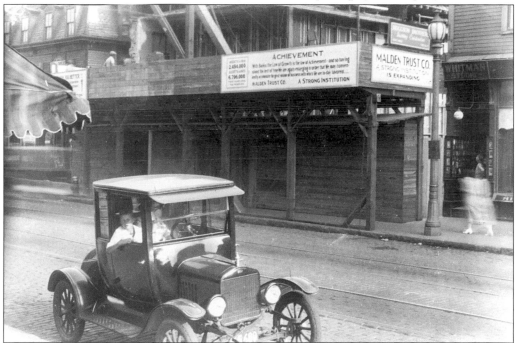

The new Malden Trust Company building was under construction when this photograph was taken on September 1, 1923. The contractors were Hodgson Brothers of New York and Chicago.

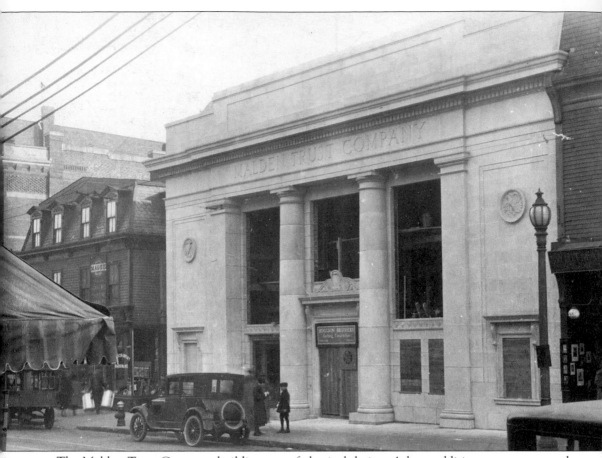

The Malden Trust Company building was of classical design. A later addition was constructed in the late 1980s and replaced the Grand Army of the Republic Hall on the right. The Malden Trust Company was absorbed by Eastern Bank in the early 1990s.

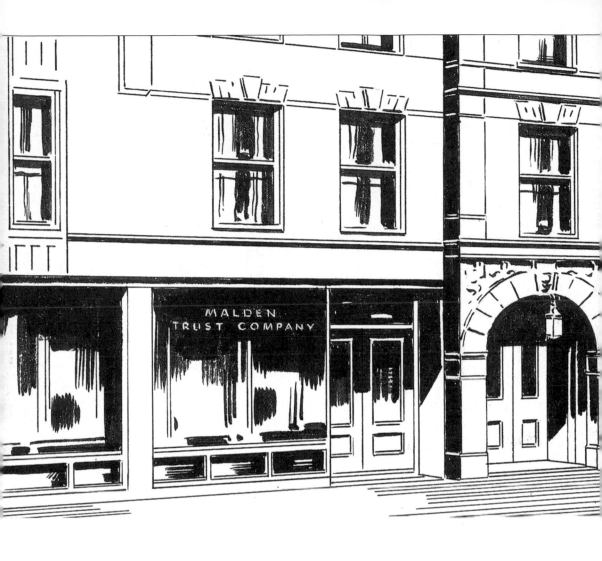

A number of sketches by D.C. Wolf were used by the Malden Trust Company in its advertising. This sketch depicts the first office of Malden Trust on the first floor of the YMCA Building on Pleasant Street across from the present Eastern Bank.

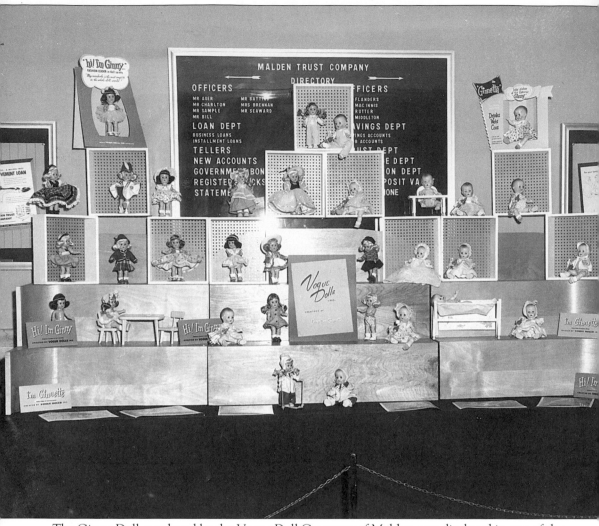

The Ginny Doll, produced by the Vogue Doll Company of Malden, was displayed in one of the many business expositions sponsored by the Malden Trust Company.

Nine

CELEBRATIONS

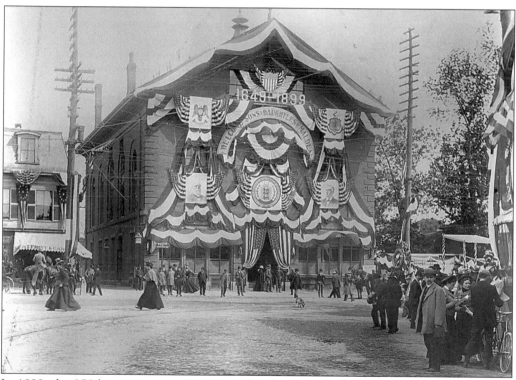

In 1899, the 250th anniversary of Malden's founding was the largest celebration ever seen in the city. Held May 20–23, 1899, it included a parade, banquets, a formal ball, sporting and musical events, and a balloon ascension at Ferryway Green attended by 10,000 people. One full day was devoted to children's activities. In this view, Malden City Hall was dressed up for the occasion. Public buildings and businesses throughout the city were festooned with bunting and flags in celebration.

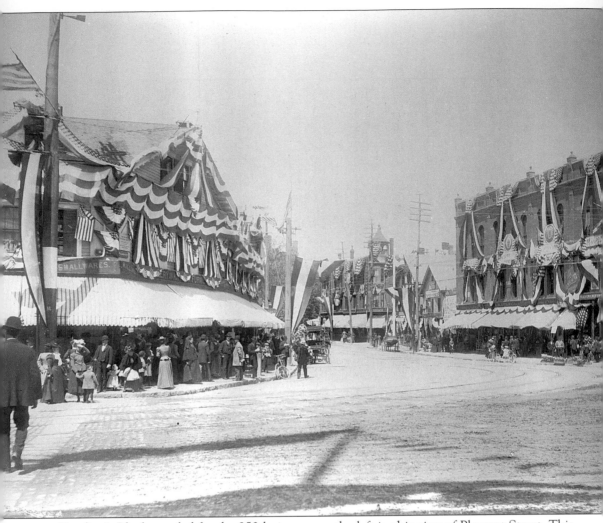

Dowling's Block, regaled for the 250th, is seen on the left in this view of Pleasant Street. This later became the site of the present Dowling Building. The photograph was taken from Central Square looking west. The Varnick Building, which later housed the Granada Theatre, is on the right.

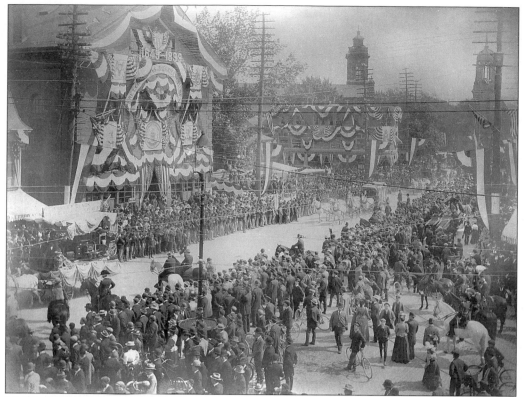

Visible in the distance in this photograph of Central Square are Sacred Hearts Church on the left and the First Parish Universalist Church on the right.

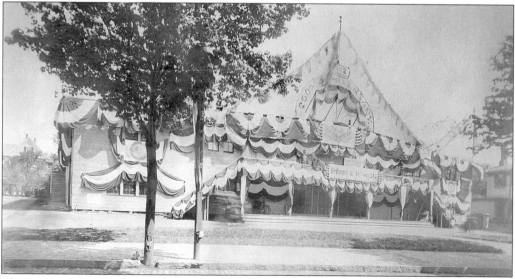

The city appropriated $17,500 for the 250th Anniversary Celebration. Some of the money was used to erect a temporary building called the Anniversary Building on Pleasant Street opposite the present Masonic Building. Elisha Converse erected the temporary structure shown here on the site later occupied by the Auditorium Theatre. It was the site of a huge banquet, a formal ball with guests in full evening dress, and many other programs.

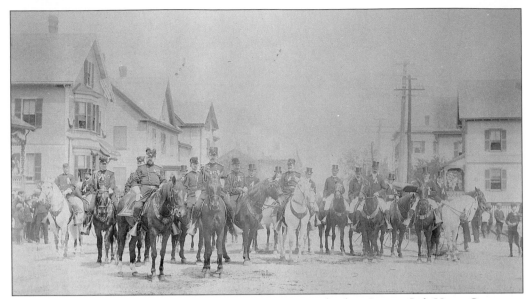

Parade formation took place on Highland Avenue near Thacher Street. Col. Harry Converse, the son of Malden's first mayor Elisha Converse, is on the horse third from the left and was chief marshal of the parade. The Immaculate Conception School is visible in the background.

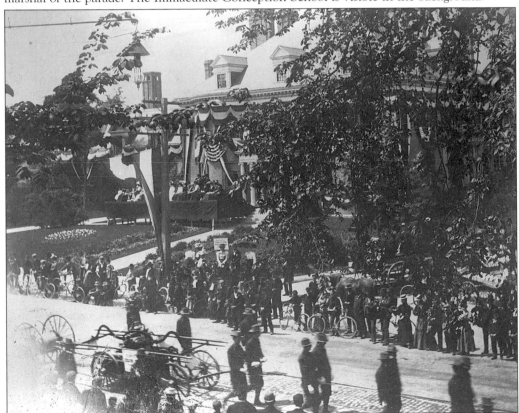

Guests had choice seats as they viewed the parade in style from A.H. Davenport's magnificent home on Salem Street. Note an old fire pumper in the foreground.

An exhibition of historical artifacts was gathered for display during the 250th Anniversary Celebration. The Historic Loan Exhibition, held at the Malden YMCA, building was so popular it was held over for an extra day.

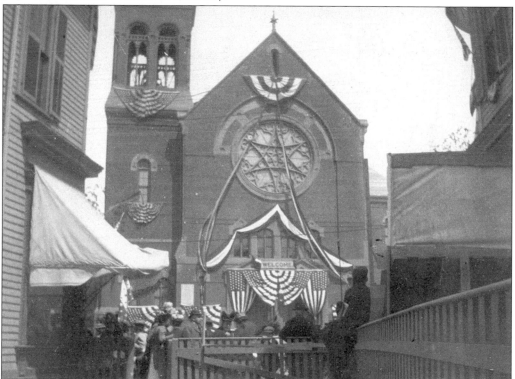

The Centre Methodist Church, which is seen from the alley across Pleasant Street, participated in the celebration along with the rest of Malden's churches.

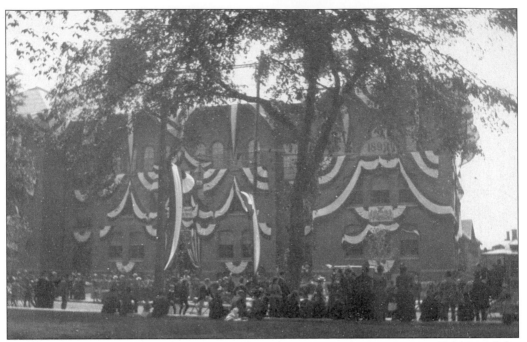

The newly built high school, located on Salem Street opposite the First Baptist Church and the Converse Memorial Building, is shown dressed for the occasion in this snapshot.

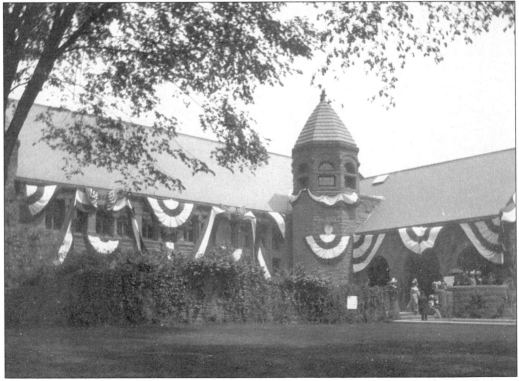

The Converse Memorial Building, more commonly known as the Malden Public Library, was regaled in bunting for the celebration.

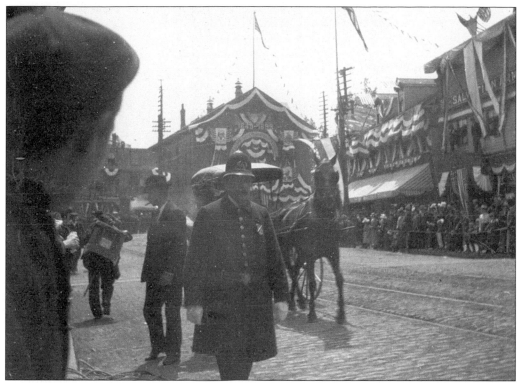

The original photograph bears the ironic notation "Half the police force" but gives a front-row view of the parade scene from Central Square; Joslin's Department Store is on the right. Joslin's later was sold to the Jordan Marsh Company, which operated the business at this site until it moved to the Assembly Square Mall in Somerville in the early 1980s.

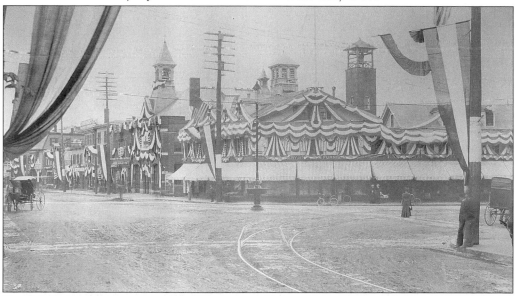

Central Square, the intersection of Pleasant and Main Streets, was a glorious sight during the 250th Anniversary Celebration. Dowling's Block is in the foreground. In the rear to the left is the cupola of the Central Firehouse and to the right, its tall hose-drying tower.

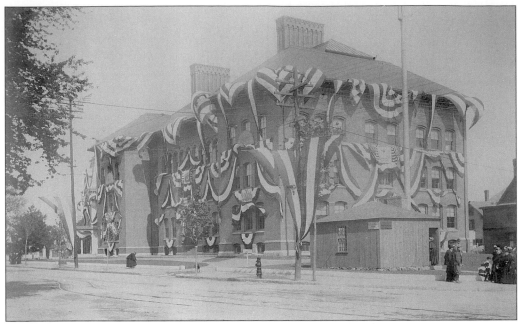

Malden High School is decorated for the 250th Anniversary Celebration. On its lawn is a replica of the first schoolhouse in Malden. The original schoolhouse was actually located on the site of the present Dowling Building, near the corner of Main and Pleasant Streets.

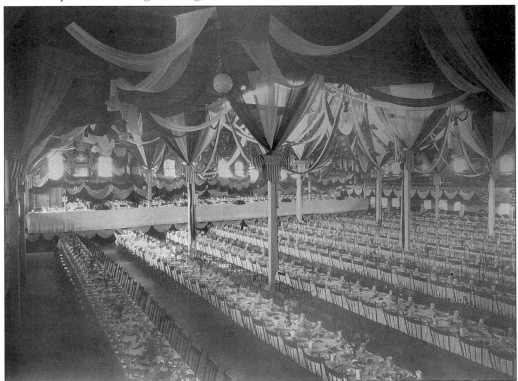

The interior of the temporary Anniversary Building is shown set up for the banquet. Specially commissioned blue and white Wedgewood plates were given as a souvenir to each guest.

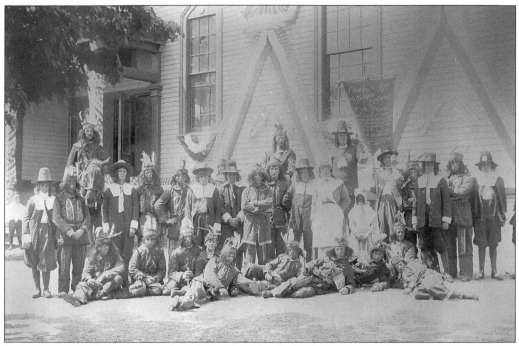

Participants in the parade included the St. Mary's Catholic Total Abstinence Society, seen here in costume.

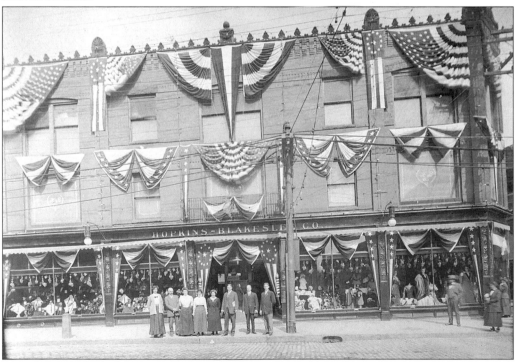

The Hopkins-Blakeslee Company, seen here in 1911, was located at 45 Pleasant Street, at the corner of Dartmouth Street in Malden Square. This was later the site of the Boston Leader store.

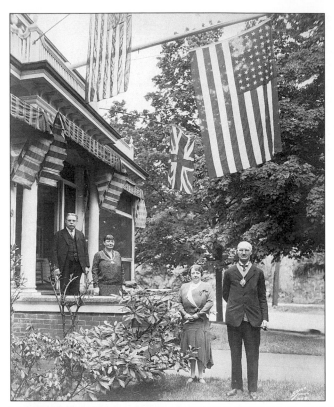

Mayor and Mayoress Clarke of Maldon, England, are shown visiting Mr. and Mrs. William Winship at their residence at the corner of Maple Street and Fellsway East during the Massachusetts Bay Colony Tercentenary in May 1930. Shown are, from left to right, William Winship, Mayoress Clarke, Mrs. Winship, and Mayor Clarke.

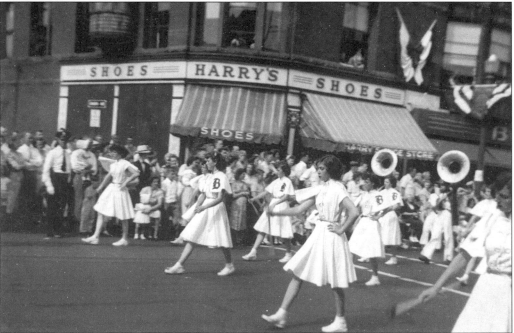

During the week of June 12, 1949, Malden celebrated its tercentenary. One of the highlights was a parade consisting of ten divisions. In this photograph, the Beebe Junior High School Band is seen as it passes the YMCA building on Pleasant Street.

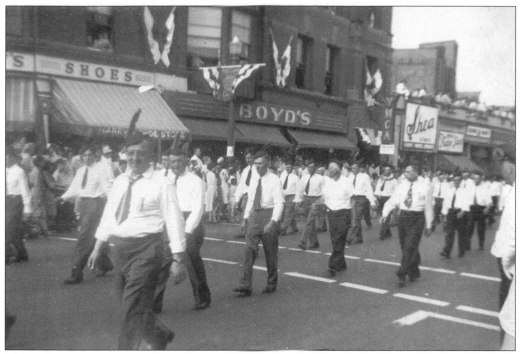

The Italian-American Citizens Club was one of the many units representing organizations of Malden's proud multinational heritage in the 1949 parade. Frank DiGiammarino, owner of a local grocery store, is the marcher with a feather in his cap.

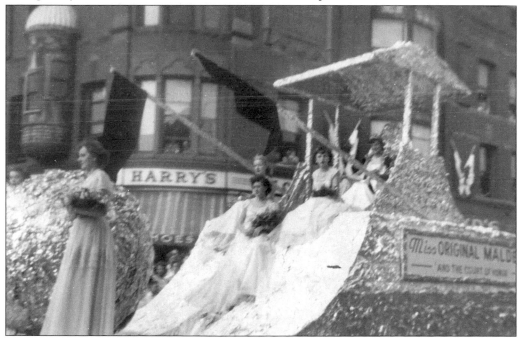

Rose Mayo, a 17-year-old resident of Sterling Street in the Edgeworth section of Malden, was Miss Original Malden for the Tercentenary Celebration. Suzanne Buonopane, not pictured, was Miss Malden Tercentenary.

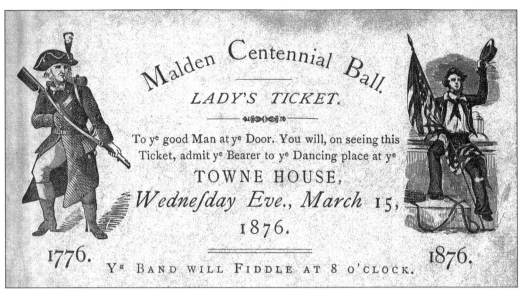

In 1876, Malden celebrated the nation's centennial with a ball and other activities. This ticket was designated as a Lady's Ticket. It is not known whether men had a separate ticket.

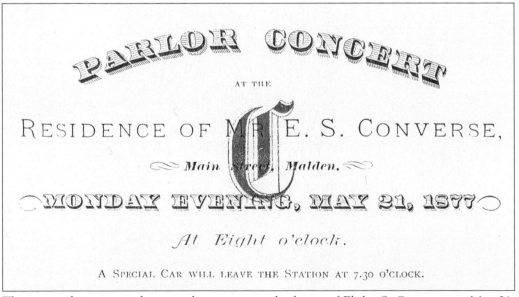

This is an admission card to a parlor concert at the home of Elisha S. Converse on May 21, 1877. The evening's entertainment included a quartet, pianists, and readings. Converse's home was located on the west side of Main Street near the Everett line.

Ten
WARTIME

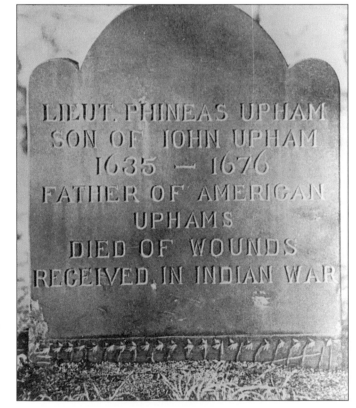

This memorial honors Lt. Phineas Upham, who was wounded in King Philip's War and died a year later from his wounds. The Uphams were an early and prominent Malden family who settled in the part of Malden that is now known as Melrose. Bell Rock Cemetery contains the remains of 32 Revolutionary War veterans, whose names are listed on a plaque at the cemetery gate.

LIEUT. PHINEAS UPHAM
SON OF IOHN UPHAM
1635 — 1676
FATHER OF AMERICAN
UPHAMS
DIED OF WOUNDS
RECEIVED IN INDIAN WAR

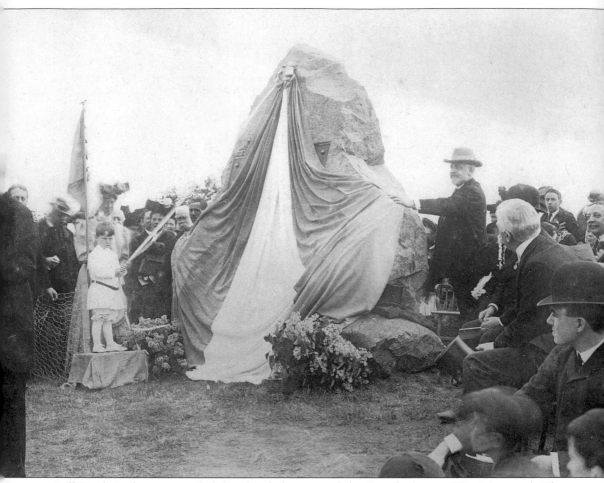

Bell Rock Park was crowded for the dedication of the Revolutionary War Memorial. This memorial was moved to Bell Rock Cemetery when the Soldiers and Sailors Monument was erected in 1910.

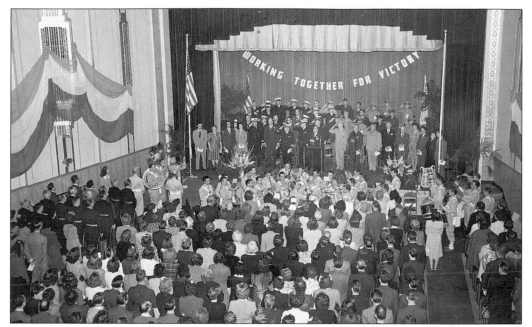

The National Radio Company was established in 1914 and was located at the corner of Exchange and Middlesex Streets. Here, in 1942, company officials are seen in Jenkins Auditorium at Malden High School receiving the Army-Navy E Award for excellence in the war effort. National Radio later changed its name to the National Company and moved to Main Street in Melrose, just over the line from Malden.

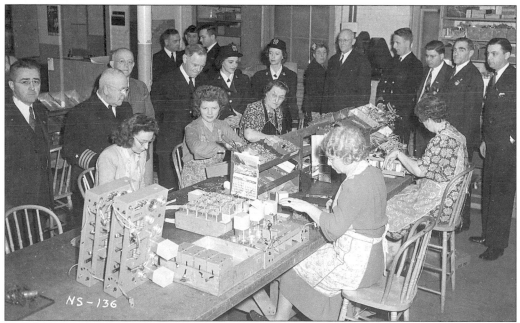

Visitors from the Navy Department tour the National Radio Company after attending the E awards ceremony. National Radio produced communication receivers used by the U.S. Navy and the navies of many Allies during World War II. In this photo, an engineer tests a piece of equipment. Walter Balhe, an officer of the company, is standing fifth from the right.

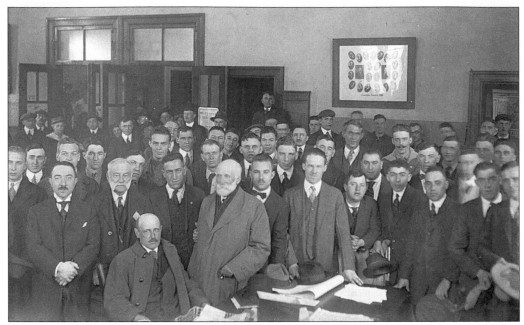

George L. Richards was the chairman of the Malden War Commission during WWI and recorded and preserved the records, including a collection of photographs, of Malden men who served in the war. Richards was a physician and the mayor of Malden in 1908 and 1909. The second quota of men who were drafted is shown in this photograph taken in the Common Council Chamber inside the old city hall.

The first two Malden men drafted into service were Jacob Schrank and Joseph Gilman, who appear in this photograph.

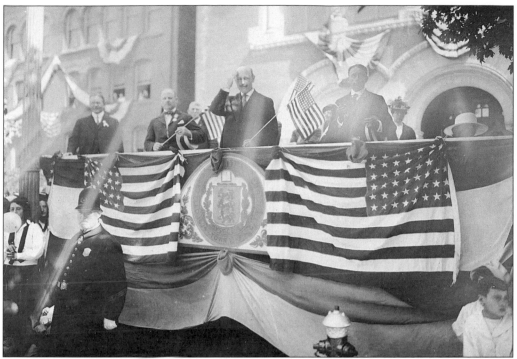

Mayor Charles M. Blodgett delivers a farewell address to the men in front of the red brick Malden High School in 1917.

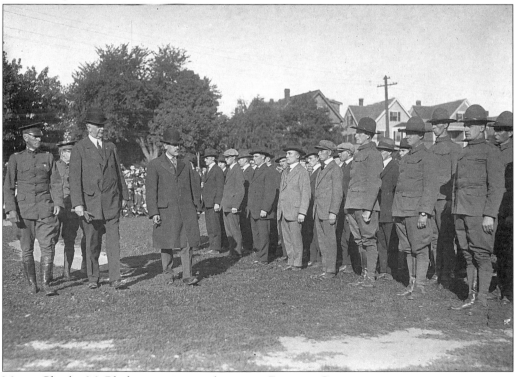

Mayor Charles M. Blodgett reviews inductees at Ferryway Green.

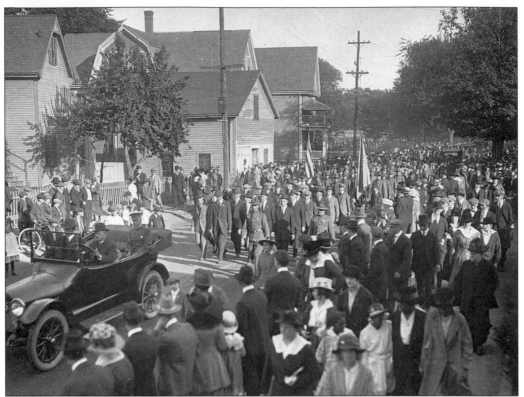

A farewell at Ferryway Green was given on August 25, 1917, by the city to the young men of Company L, 5th Infantry, Massachusetts National Guard. Here, the group marches down Walnut Street from Ferryway Green.

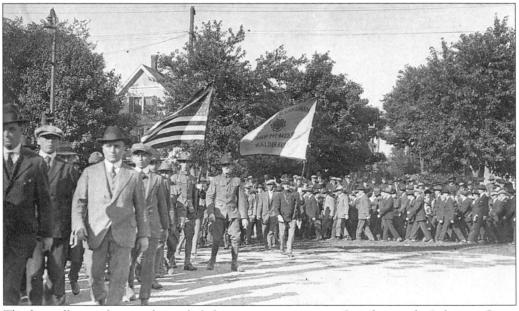

The farewell given by city also included many veterans groups. Seen here is the Lakeman Camp No. 44 of the United Spanish War Veterans, who participated in the day's affairs.

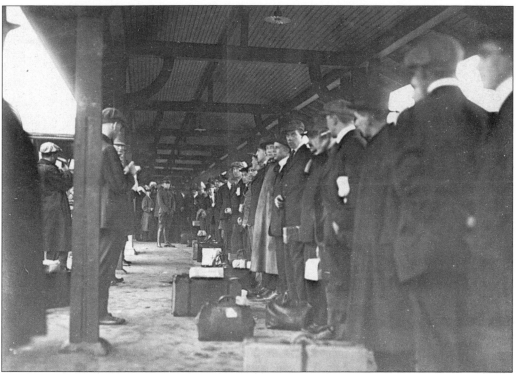

This view shows the men lining up at the Malden Station on Summer Street to await the train for departure for military service. A large crowd saw the contingent off.

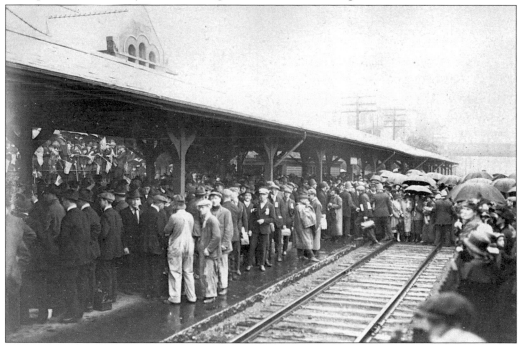

Inductees are shown waiting at Malden Station. Families and well-wishers can be seen in the rear of the photograph.

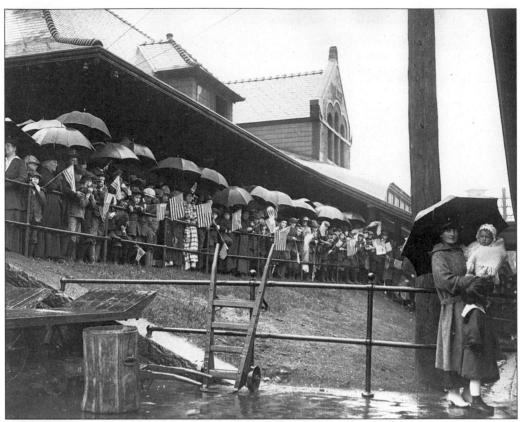

The second quota of drafted men is seen waiting for the train at Malden Station. It was a proud moment when the Malden families turned out to see their sons off; the rain did not dampen their spirits.

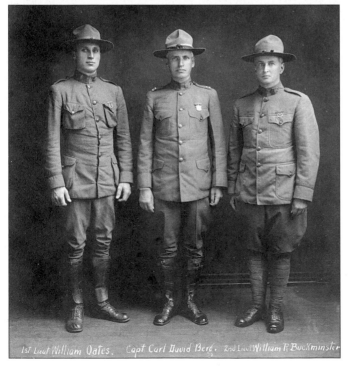

1st Lieut William Oates. Capt Carl David Berg. 2nd Lieut William R Buckminster

Officers of Malden's Company L, 5th Regiment, Massachusetts Infantry during WWI were, from left to right, 1st Lt. William Oates, Capt. David Berg, and 2nd Lt. William R. Buckminster.

The original armory on Mountain Avenue was constructed in 1884 and was headquarters of the Malden Rifles, Company L, of the Massachusetts National Guard. It housed drill halls and offices. It was demolished to make way for the present armory built in the early 1900s.

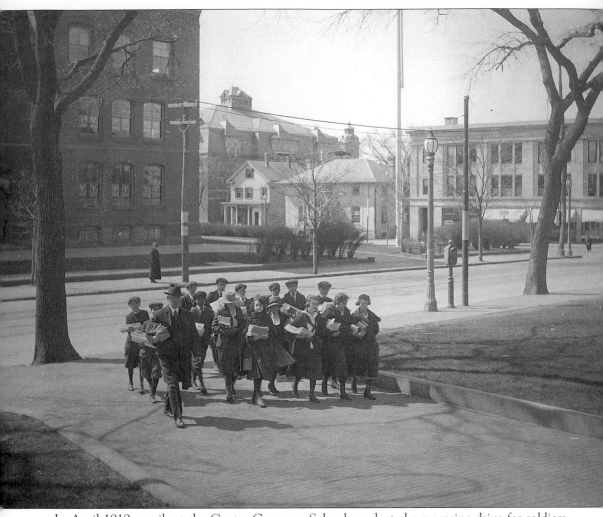

In April 1919, pupils at the Centre Grammar School conducted a magazine drive for soldiers and sailors serving in WWI. Shown here are Principal Richard W. Nutter and his students entering the public library with their donations.

Eleven

SOCIAL LIFE
OF THE CITY

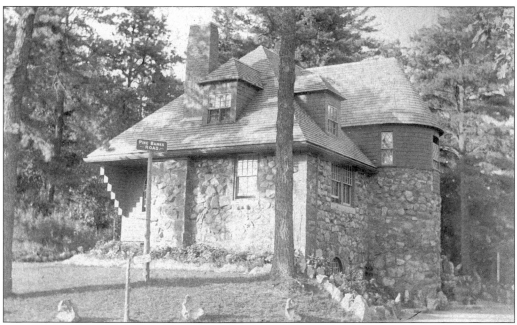

The Pine Banks Lodge was originally built as a lodge for Elisha Converse's family. It now houses the park office and is home to the superintendent. Pine Banks Park was bequeathed to the cities of Malden and Melrose in 1904 by Elisha Converse.

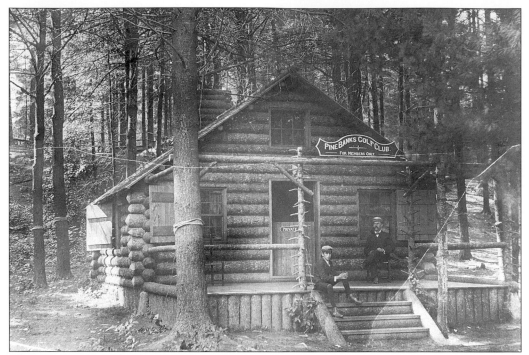

The Pine Banks Golf Club is seen here *c.* 1900. This was one of three log cabins on the Pine Banks property. The Converse family opened the grounds to the public before the property was donated to Malden and Melrose. The area on which the ball fields are now located was once called "the links" and was the site of an early golf course.

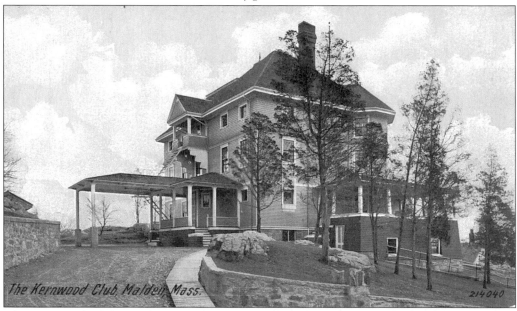

The Kernwood Club on Alpine Street was one of Malden's most exclusive social clubs dating from the beginning of the 20th century. It survived until the mid-1950s, when the building was sold and briefly used as a Sons of Italy Lodge. It was razed for an apartment building in the 1970s.

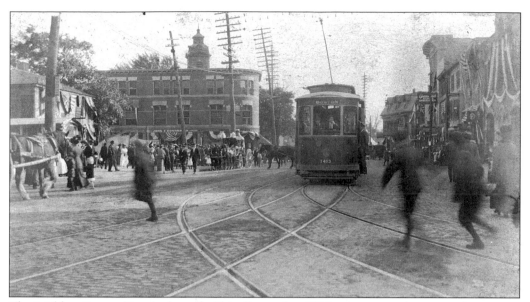

The Malden Square Carnival was held in September 1912 to promote downtown businesses. Hills Tavern and Morton's Block are at seen at the left. Today, this is the intersection of Main and Irving Streets. The U.S. Trust bank sits on the site of Morton's Block today.

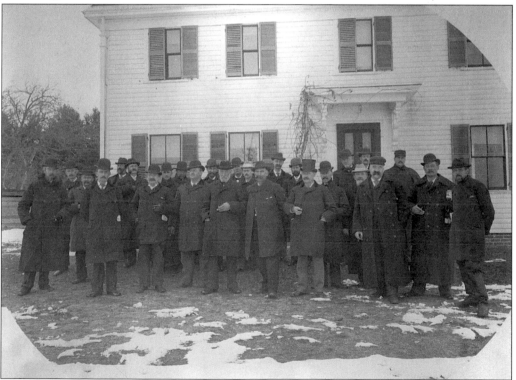

Members of the Martin's Pond Committee are pictured here. Although not widely known today, Martin's Pond in Reading was once considered as a possible source of water for Malden residents. Water supply was a pressing concern for city officials as Malden developed rapidly in the late 1800s.

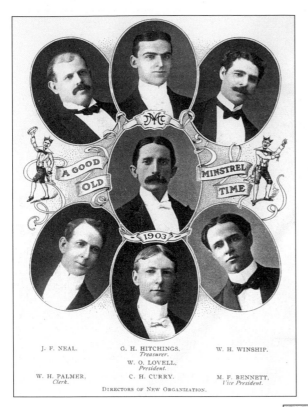

J. F. NEAL. G. H. HITCHINGS, *Treasurer.* W. H. WINSHIP.

W. O. LOVELL, *President.*

W. H. PALMER, *Clerk.* C. H. CURRY. M. F. BENNETT, *Vice President.*

DIRECTORS OF NEW ORGANIZATION.

A page from a Malden Megatherians program of 1903 shows the troupe's principal players. The Megatherians, an amateur group made up of Malden residents, first performed in 1893 and followed in the traditions of earlier Malden concert groups, such as the Malden Serenaders, the ABC, and the Kernwood Club burlesque.

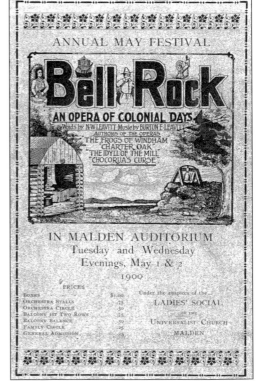

Culture was alive and well when Malden residents produced the Bell Rock Opera in May 1900. This, "opera of colonial days" refers to Bell Rock, the site of the first meetinghouse in Malden.

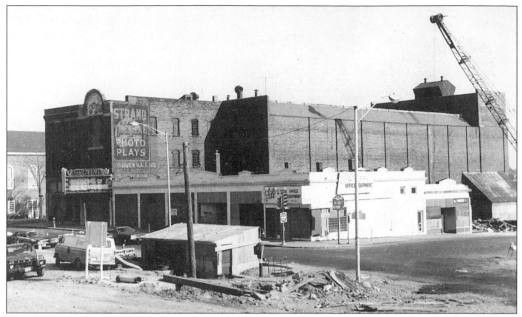

The Strand Theatre, located on Pleasant Street and the corner of the original Abbott Street, was one of six movie houses in downtown Malden. It opened in April 1922 and seated 1,900 persons. The theater presented vaudeville acts and a selection of motion pictures. It operated until 1966 and was demolished in 1973 for urban renewal. Its location is the present site of the police station.

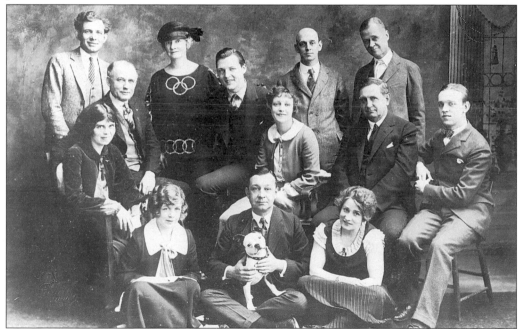

Many of the movie cinemas in Malden started out as dramatic theaters. The Strand and the Auditorium presented plays performed by their own respective stock companies. This photograph shows the entire stock company of the Auditorium Players for the 1923–1924 season. Individual performers also had their own publicity pictures.

Frances Staniford was a member of the Temple Stock Company of the Malden Auditorium

Rogers Barker was another member of the Temple Stock Company of the Malden Auditorium.

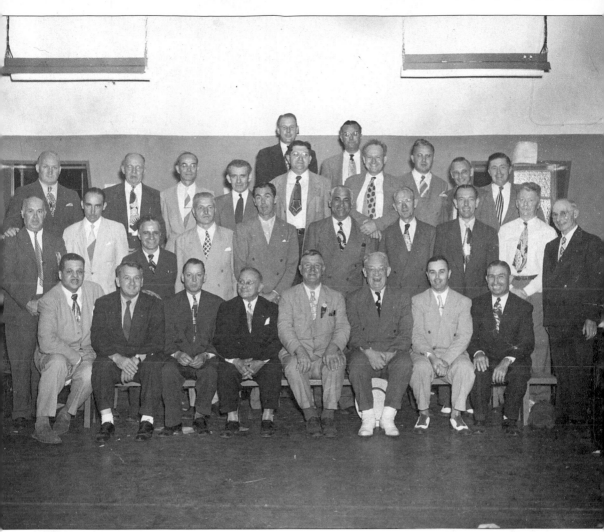

From the 1930s through the 1980s, the Ex-Aldermen's Club was a prominent group of politicians, both past and present. The club's crow supper was one of Malden's most popular events through the early 1980s. In the front row are Herbert L. Jackson, left, and three former mayors: Vernon Newman, third from left; John Devir, sixth from left; and Fred Lamson, seventh from left. Can you identify the others?

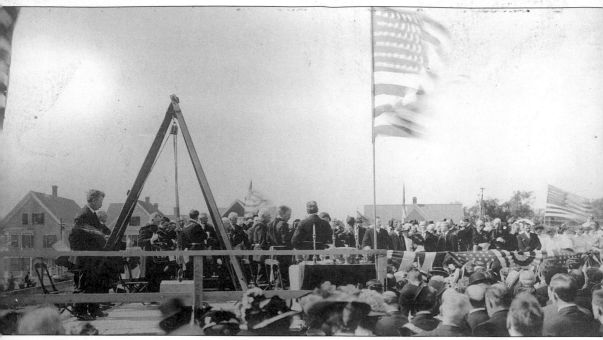

Representatives of the Malden Post of the Grand Army of the Republic and Malden Masonic lodges were present at the laying of the cornerstone for the Soldiers and Sailors Memorial in Bell Rock Park on Memorial Day in 1909. The ceremonies were led by Dana J. Flanders of Malden, who at the time was the grand master of Massachusetts. The memorial features a bronze statue entitled "The Flag Defenders," by sculptor Bela Pratt, and has recently become the focus of restoration efforts.

For many years, a children's health camp was located atop Waitt's Mount. The staff of the Malden Children's Health Camp was responsible for providing outdoor treatment and medical supervision to anemic children who attended the camp. For as long as the camp was run, local women's and civic groups held an annual Saturday Carnation Day to raise funds for its support.

The camp's buildings are shown as they appeared at the top of Waitt's Mount, the highest point in Malden. Waitt's Mount was used as a lookout during the Revolutionary War and as an antiaircraft battery during WWII. The buildings were removed after the camp closed in the early 1960s.

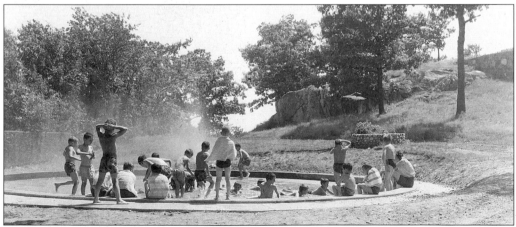

Children frolic in the camp's pool in this view c. 1960. Upward of 50 children a year were cared for during the summers that the camp was in operation.

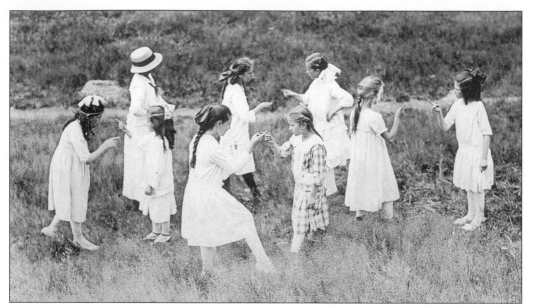

Miss Ida MacKenzie's Vacation School was held at Bell Rock Park in 1916. Here, some of the school's young students are engaged in learning folk dancing.

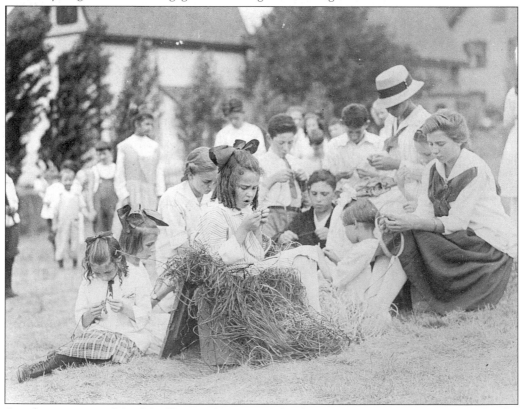

Another activity at Miss MacKenzie's Vacation School was straw weaving, or raffia work. The sunny skies at Bell Rock Park in the summer of 1916 appear to be conducive to the children's efforts and their enjoyment.